C000256734

HERTFORDSHIRE'S HISTORIC INLAND WATERWAY

Batchworth to Berkhamsted

John Cooper

AMBERLEY

Also by John Cooper

A Harpenden Childhood Remembered: Growing up in the 1940s & '50s

Making Ends Meet: A Working Life Remembered

A Postcard From Harpenden: A Nostalgic Glimpse of the Village Then and Now

Watford Through Time

A Postcard From Watford

Harpenden Through Time

Rickmansworth, Croxley Green & Chorleywood Through Time

To my darling wife Bet and all the family.

First published 2015

Amberley Publishing
The Hill, Stroud, Gloucestershire, GL5 4EP
www.amberley-books.com

Copyright © John Cooper, 2015

The right of John Cooper to be identified as the
Author of this work has been asserted in accordance with
the Copyrights, Designs and Patents Act 1988.

ISBN 978 1 4456 5297 9 (print)
ISBN 978 1 4456 5298 6 (ebook)

All rights reserved. No part of this book may be reprinted
or reproduced or utilised in any form or by any electronic,
mechanical or other means, now known or hereafter
invented, including photocopying and recording, or in
any information storage or retrieval system, without the
permission in writing from the Publishers.

British Library Cataloguing in Publication Data.
A catalogue record for this book is available from the
British Library.

Typesetting by Amberley Publishing.
Printed in Great Britain.

Introduction

Skippered by Malcolm Price and with Andrew Murray on the tiller, the wide-beam narrowboat *Close Shave*, contrary to its name, was expertly manoeuvred into Lock No. 73 at Hunton Bridge, ably assisted by crew members Marion Roberts and Brian Frost. With a group of ladies from Harpenden Pilates Club on board thoroughly enjoying a lovely spring day-trip out, *Close Shave* is one of three craft owned by the prestigious local canal-boating firm Waterways Experiences, a prime example of how far the emerging pleasure boat business has come to the inland waterways network since the gradual decline of the traditional working boat.

But where did it all begin?

Although the Romans had dug a number of canals in Britain, including the Foss Dyke (or Fossdyke) in circa AD 120 connecting the River Trent at Torksey and the River Witham at Brayford, the first canal in England, independent of a river, is credited to the Bridgewater Canal built by the 3rd Duke of Bridgewater, Francis Egerton, known as the father of inland navigation. Due to the high charges of transporting coal from his mines at Worsley to Manchester, the duke sought to find a cheaper and more efficient means of moving the coal. Together with his agent John Gilbert, an experienced mining engineer, and James Brindley, an equally experienced millwright who, although he understood how to survey water courses, had to learn about canal planning and construction by actually doing it, Egerton's work on the Bridgewater Canal commenced in 1760 and was completed a year later.

Following the success of the early canals, such as the Bridgewater and the Trent and Mersey, further inland waterways started to be constructed in other parts of the country. With large gangs of labourers known as navigators, hence the present-day word navvy, in place, and using just picks, shovels, wheelbarrows and horse-and-carts, digging commenced on the Hertfordshire section of the Grand Junction Canal, which was eventually completed in 1797/8.

Previously, freight carried from Braunston to London had travelled via Oxford along the Oxford Canal, a distance of 250 miles. A new more direct canal was proposed that would reduce the total distance by 60 miles. Promoted by the Marquis of Buckingham, the planning of this project took place at the Bull Inn in Stony Stratford during the summer of 1792 and, following the passing of a successful Act of Parliament, a start date was scheduled for 1793. As was expected, the Oxford Canal proprietors were against the proposal to short-circuit the Braunston to London route. A compromise was eventually reached whereby compensation tolls were paid by the Grand Junction Canal Company to the Oxford Canal Company should their revenue ever fall below £10,000 a year.

Our 14-mile journey on what is arguably the most picturesque stretch of waterway in the county starts at Stocker's Lock No. 82 in Rickmansworth, where we see the house that was built for the coal-duty collector and Stocker's Farm, once used as a film set for the popular children's TV production *The Adventures of Black Beauty*. Adjacent to the canal are three scenic lakes, Batchworth, Bury and Stocker's – the latter a beautiful and peaceful nature reserve.

We pass the site of W. H. Walker & Brothers Ltd, or 'Walkers of Ricky' as they were known, who had a fine reputation as boat builders and who built many of the narrowboats on what was then the Grand Junction Canal. A short stroll along the towpath brings us to *Roger*, one

of several restored historic narrowboats that we shall we looking at in these pages, and the Canal Centre at Batchworth Lock No. 81. It is here that the Rickmansworth Waterways Trust, a heritage education charity, is based. They not only offer a variety of education programmes for school visits, but also canal cruises as well.

Further along the canal and located adjacent to Croxley Hall Farm, where the Sansom family pioneered watercress growing more than 130 years ago, and near to Lot Mead Lock No. 80 is Croxley Great Barn. This is a magnificent Grade II-listed threshing barn that dates back to the late fourteenth century, and is one of the oldest and largest of its type in Hertfordshire. Moving on to Common Moor Lock No. 79, we gaze across the canal to where John Dickinson opened Croxley Mill in 1830, one of several paper mills along the waterway owned by Dickinson – now all gone.

Adjacent to Rousebarn Lane Bridge No. 168 is the Cassiobury Farm & Fishery, a fascinating 15-acre site where an open farm has been developed with newly planted watercress beds and several species of exotic animals. Continuing along the towpath we arrive at Ironbridge Lock No. 77 in the lovely Cassiobury Park, once part of the estate of the Earls of Essex and always a popular venue for the many visitors who enjoy the park each year, and the magnificent Grove, previously the family seat of the Earls of Clarendon.

Canalside industries thrived, especially the prosperous paper mills of John Dickinson at Apsley, Nash and Home Park; the Wander factory at Kings Langley, where once the world famous malt extract drink Ovaltine was produced; and Toovey's Mill, one of several old flour mills that were dotted along this stretch of the waterway. Both John Dickinson and Wander had their own fleet of narrowboats.

Waterside inns such as the Fishery Inn at Boxmoor, the Three Horseshoes at Winkwell and three delightful pubs at Berkhamsted – the Rising Sun, the Boat and the Crystal Palace – are all popular venues to regulars and boaters alike. We stop for a moment in Boxmoor, where James Snook, the last highwayman to be executed at the scene of his crime in England, lies buried in a grassy meadow a short distance from the towpath.

Finally we arrive at our destination of Berkhamsted, an historic market town with its ruins of the eleventh-century castle. Here the canal meanders through the picturesque and once thriving Port of Berkhamsted, still a lovely place to pause for a while to reminisce on the sights, the history and the people that we have met on this fascinating and absorbing journey that has taken us along the Grand Union Canal from Batchworth to Berkhamsted.

Acknowledgements

I am extremely grateful to the following for their kind assistance in providing photographic archive material, for their helpful and constructive advice and comments, and for giving me the benefit of their specialised, local history and narrowboat/canal knowledge – all greatly appreciated, and without which this book could not have been produced:

John Bennett, Waterways Experiences; John Benson, Canal & River Trust; Christine and Alan Betts; Paul Botje, Frogmore Paper Mill; Steve Cardell, Cassiobury Farm & Fishery; Reuben Carrdus, Bridgewater Basin; John Castle; Tim Codd, Waterways Experiences; Tony Cowham, Halcyon of Bushey; Francesca Davis, Frogmore Paper Mill; Tone and Julie Ferne; Peter Field, Kings Langley Local History & Museum Society; Mary Forsyth; Brian Frost, Waterways Experiences; Ralph Gregory, Canal & River Trust; Peter Hadwin, Watford Piscators; David Harding; Fabian Hiscock; Hugh Howes; David Huggins; Peter King; Prue King; Peter Lincoln, South West Herts Narrowboat Project; Jean Machin; Brian Morgan, Phoenix Jazz Band; John and Cynthia Morgan; Andrew Murray, Waterways Experiences; Brian Nicoll; Margaret Parsons; Jim Patterson, Paper Maker, Frogmore Paper Mill; Jennifer Penney; Alan Penwarden, Kings Langley Local History & Museum Society; Malcolm Price, Waterways Experiences; Frank Riches, Bridgewater Basin; Marion Roberts, Waterways Experiences; Alan Russell, Bury Lake Young Mariners; Paul Samson-Timms; Mark Saxon, Rickmansworth Waterways Trust; David Scott; Jenny Sherwood, Chairman, Berkhamsted Local History & Museum Society; David Spain; Mike Stanyon, Hon. p/t Archivist, The Apsley Paper Trail; Simon Topliss, Cassiobury Farm & Fishery; Lindy Weinreb; Roy Wood, Hon. Secretary, Hemel Hempstead Local History & Museum Society; Tim Woodbridge; Eric Woodward, President, West Herts Golf Club and Roger Yapp, Chairman, Abbots Langley Local History Society.

Special thanks are extended to my wife Betty for her constant support, encouragement and invaluable assistance along the towpath between Rickmansworth and Berkhamsted, to my son Mark for his continuous IT support and to my publishers, Amberley Publishing, for their kind assistance in producing this publication.

Every endeavour has been made to contact all copyright holders, and any errors that have occurred are inadvertent. Anyone who has not been contacted is invited to write to the publishers so that a full acknowledgement may be made in any subsequent edition of this book.

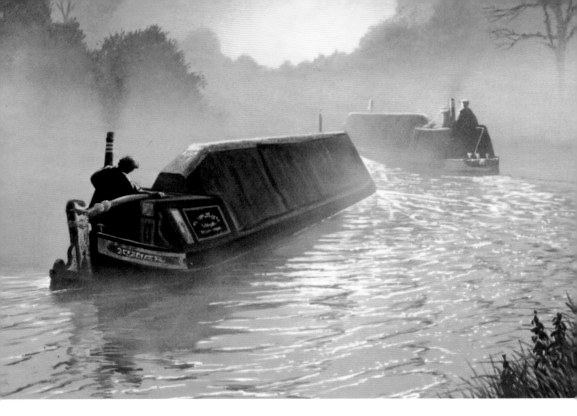

Dawn to Dusk

As dawn breaks, two fully laden working narrowboats glide into the early mist of a sunny morning, no doubt bound for one of the canalside industries based further up the cut. In the evening, as twilight approaches, we witness a tranquil scene below on a peaceful stretch of the Grand Union Canal at Rickmansworth as several boats find their moorings for the night.

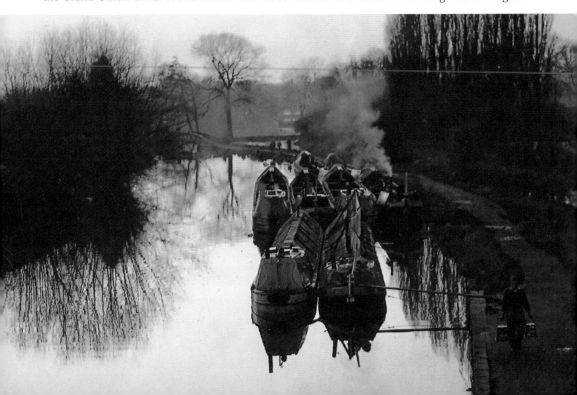

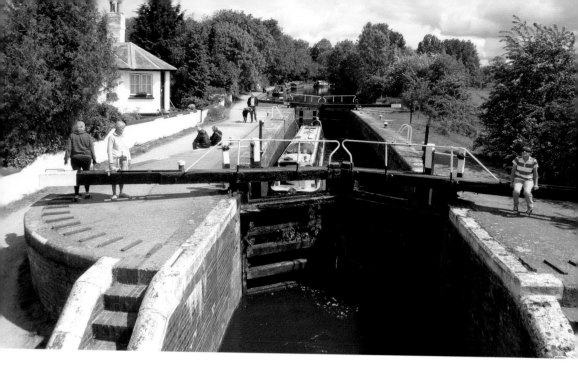

Stocker's Lock (1)

The view from Bridge No. 175 on a beautiful May morning shows Stocker's Lock No. 82 on the Grand Union Canal looking in the direction of Batchworth. The white building on the left is the old lock keeper's cottage. With the final day of the annual award-winning Rickmansworth Festival about to commence, the popular Phoenix Jazz Band, making a welcome return, are seen preparing to embark with their instruments onto the small launch that will take them, playing all the way, to Batchworth Lock for their mid-morning gig.

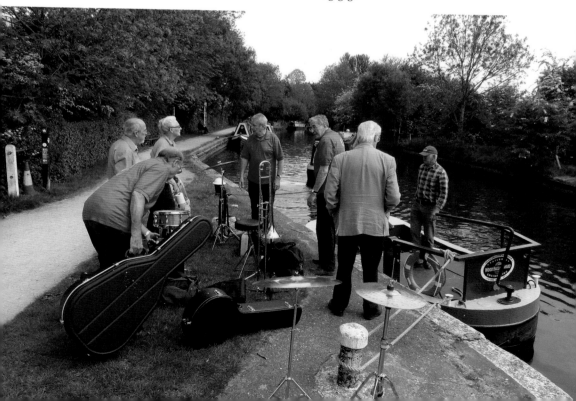

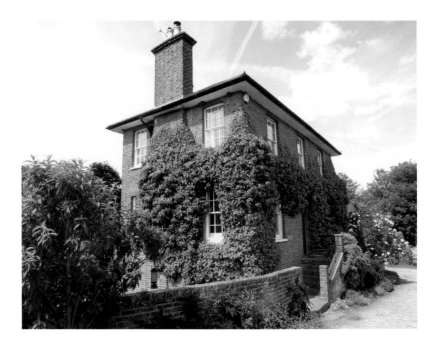

Stocker's Lock (2)

This ivy-covered dwelling at Stocker's Lock was once the home of the coal-duty collector.

Originally, all coal from the north-east collieries was transported by sea to the riverside wharves of the City of London. This made the collection of duties relatively easy. By the nineteenth century, with the increase in trade by canal and rail, the catchment area for these new modes of transport was extended. Duties were originally collected at Grove Park, but with the boundary change of 1861 a collection point was established at the county border between Springwell and Stocker's locks, with a stone obelisk being erected beside the towpath to mark the exact spot. The collection of dues finally ended in 1890. The tranquil image below shows Stocker's Farm through the arch of Bridge No. 175. It was here at the farm that many TV and movie productions were filmed, including the children's 1972 TV series *The Adventures of Black Beauty*. (Bottom picture courtesy of Tony Cowham, Halcyon of Bushey)

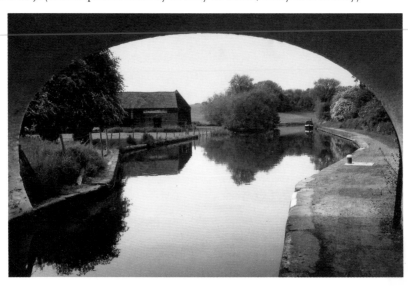

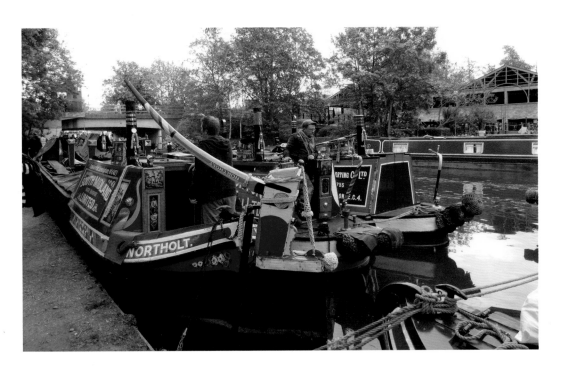

The Rickmansworth Festival

A glimpse of the effervescent carnival atmosphere of the grand finale to 'Ricky Week' – part of the Rickmansworth Festival is seen here on the towpath between Stocker's and Batchworth locks. Taking place on the third weekend in May each year at the Aquadrome and on the towpath, the venue attracts a lovely array of narrowboats from across the country, moored up to three abreast and all proudly flaunting colourful decorations of flags and bunting. Many have interesting histories as we shall see later, with several no doubt having been built by the now defunct local boatbuilder W. H. Walker & Brothers Ltd. Some of the boats have various wares and crafts on display that the numerous passers-by can purchase at reasonable cost.

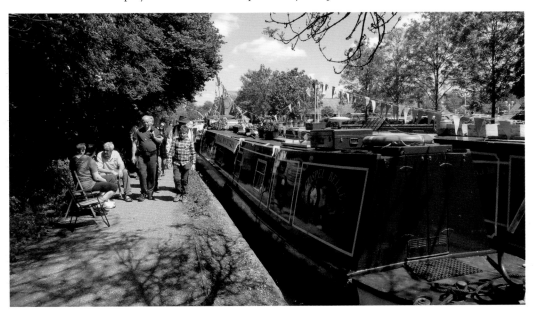

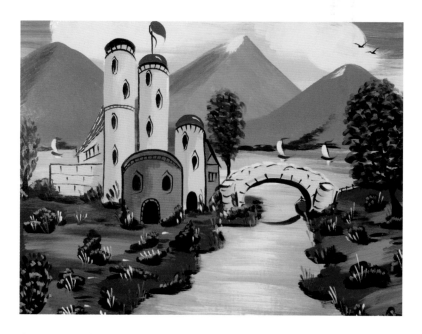

Narrowboat Decoration

During the mid-nineteenth century, the practice of decorating narrowboats, together with their fixtures and fittings, with roses and castles started to be developed, although no one really knows exactly when they first appeared or the origin of the theme. Roses particularly were exceptionally detailed, with the painting being carried out in stages. The artist, who would have been very proficient, would first sketch the outline prior to moving along the boat to paint other decorations before returning to complete the next stage of the initial outline, which would have been marked out in chalk.

Castles, too, were brightly coloured and generally adopted a similar theme of turrets, bridges, lakes and rivers, and sailing boats with bluish mountains as a backdrop, as seen in the above image. Below is the interior of a modern narrowboat, where a collection of decorated china plates are proudly displayed on one wall of the cabin. Note the radiator just below the crockery display – a welcome addition for the boater's long winter days and nights.

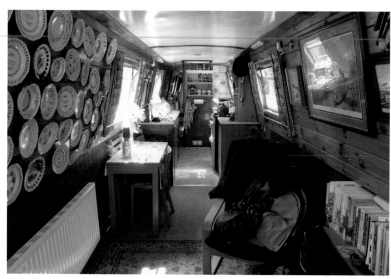

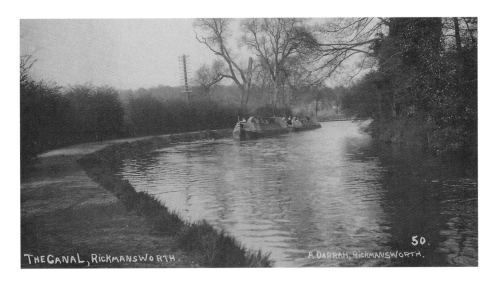

THE CANAL, RICKMANSWORTH. A. DARRAH, RICKMANSWORTH.

50.

Raymond

Raymond, the superb craft seen below and a historic narrowboat, was commissioned by the Samuel Barlow Coal Company Ltd and built at Braunston, Northamptonshire, in 1958. It was the last unpowered working narrowboat to be built there, and probably the last to be built in Britain. It was launched in true canal tradition by smashing a quart bottle of cider against the side. *Raymond* then underwent a busy working life, initially transporting coal from Baddesley Wharf on the Coventry Canal to John Dickinson's paper mills. Following the decline in work on the canals, *Raymond* was now showing the ravages of time. After extensive restoration costing in the region of £60,000, the old narrowboat has been returned to her former glory, testament to the loving care bestowed on her by a great many dedicated people. The above picture shows an early example of two narrowboats at Rickmansworth, the motor and her accompanying unpowered butty.

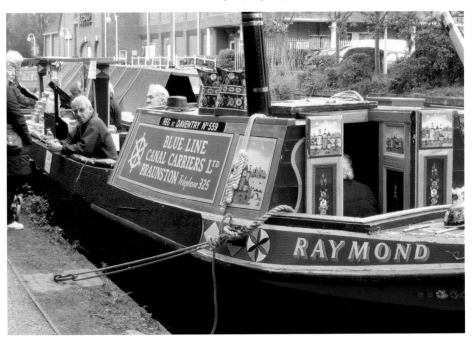

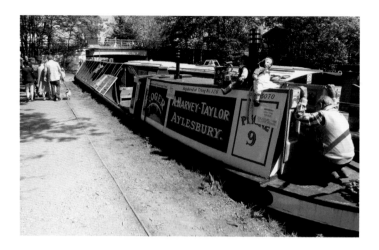

Roger

The historic narrowboat *Roger* was built at the boatyard of Charles and Joseph Bushell near Tring in 1936 for Arthur Harvey-Taylor, whose canal carrying business was located at Aylesbury. During the Second World War *Roger*, together with the butty *Daphne*, carried coal and a range of wartime cargoes with Arthur and Rose Bray in charge. In 1955, the business, including the two Harvey-Taylor narrowboats, was sold to the Samuel Barlow Coal Company Ltd. The Brays accompanied the craft and continued carrying coal from the Midlands to West London and Hertfordshire. In 1958, *Daphne* was replaced by *Raymond*.

Following several changes of ownership over the ensuing years, *Roger* was acquired by a Rickmansworth wooden-boat enthusiast in around 1986, before ownership was eventually transferred to the newly formed Rickmansworth Waterways Trust in 1993 for a complete reconstruction by a local craftsman under the direction of the trustees. The work started in 1997 and took four years to complete. Today, with the Rickmansworth Waterways Trust, now a heritage education charity, *Roger* forms a key part of the education programmes as a floating classroom, with the owners' primary duty being the conservation and presentation for operational use of this magnificent craft for the future.

Just to the right of the two narrowboats moored in the foreground of the bottom photograph, *Close Shave* and *Roger*, among the trees adjacent to the towpath was once the old Batchworth stables. Following a fire in 1956, the building was completely gutted and six boat horses were killed. The brick floor of the stables is still there and visible among the undergrowth. Some of the bricks are dated 1914 and 1915 and, although the building was much earlier, this extension would have been built after the start of the First World War.

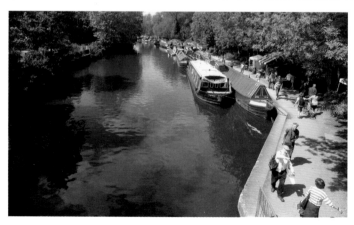

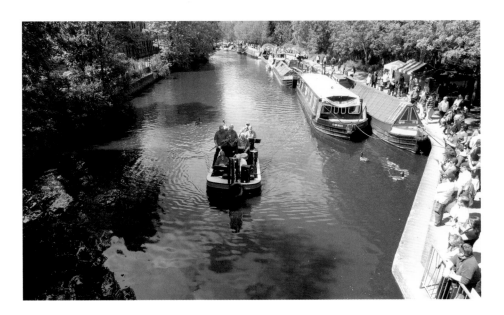

The Phoenix Jazz Band

Approaching Batchworth Bridge No. 173 is the Phoenix Jazz Band, who have travelled from Stocker's Lock entertaining the towpath crowds with their music as they go. Below, the band is seen playing their set in front of the Canal & River Trust workshops at Batchworth Lock No. 81 for almost an hour before making the return journey to Stocker's. This superb band evolved following the devastating King's Cross fire that broke out on the evening of 18 November 1987, killing thirty-one people and injuring a hundred.

In order to raise money for more research, the doctors, nurses and medical students of the Plastic Surgery and Burns Unit at University College Hospital launched an appeal by forming a jazz band. Busking started at King's Cross station and a personal appearance was later made on ITV News. The band became so popular that they continued playing for charity, literally 'the phoenix rising from the ashes' – an apt name. Two of the original members remain.

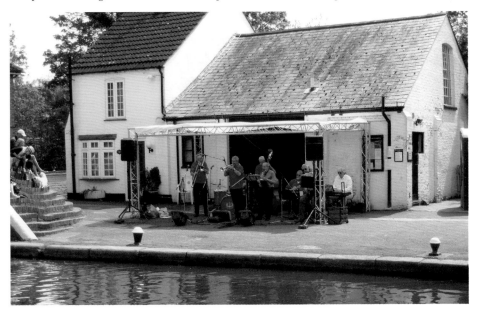

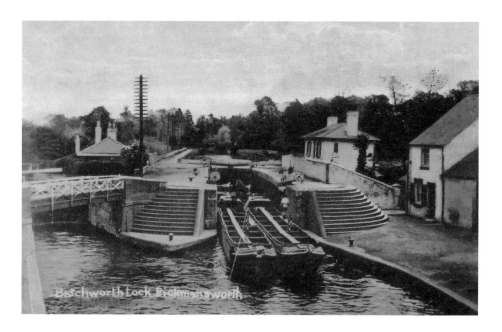

Batchworth Lock

One of the most photographed and well-known places in Rickmansworth must certainly be that of Batchworth Lock No. 81, seen here from Bridge No. 173. Around the early part of the nineteenth century there were several short branches of what was then the Grand Junction Canal constructed at Rickmansworth. The left arm at Batchworth, known as Salter's Cut, was built by Salter in 1804 to give access to their brewery, which was sited close to the town wharf, while the right lock catered for all other waterway traffic. Another short branch was used by John Taylor, a baker, to bring flour up to his bakehouse at The Bury. The view below shows the throngs of people at the lock enjoying the spring sunshine during the annual Rickmansworth Festival.

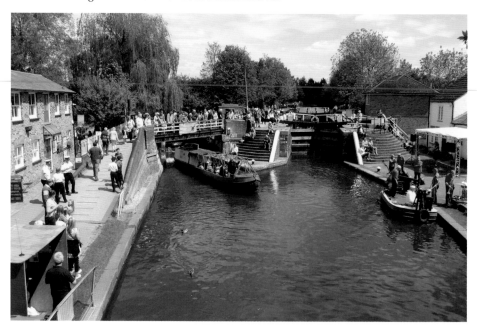

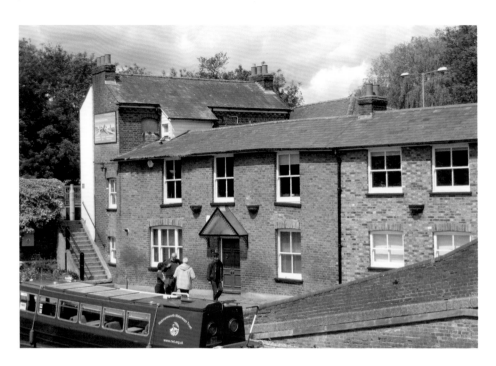

The Boat and the Railway Tavern

In days gone by, there used to be two pubs at Batchworth situated at differing levels. The bottom hostelry was the Boat, which was adjacent to the towpath and served the needs of the boat people who travelled along this stretch of waterway. It is now part of the Batchworth Lock Canal Centre. A short distance up the adjoining flight of steps to street level was the well-frequented Railway Tavern, which catered for the railway workers and passengers homeward bound from the nearby Church Street station.

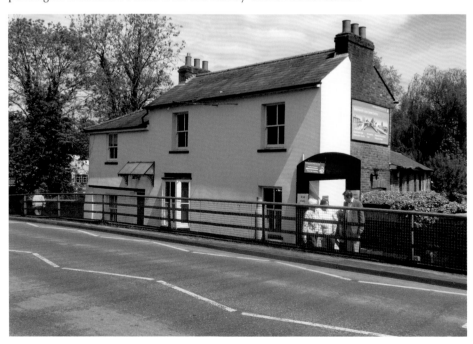

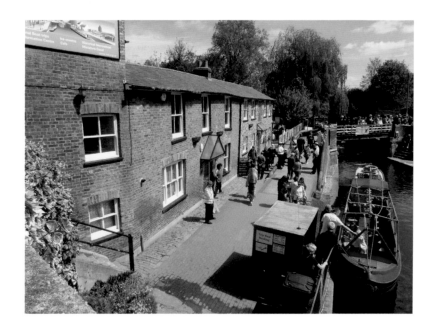

Rickmansworth Waterways Trust

Originally formed in 1991, the Rickmansworth Waterways Trust, a heritage education charity, has, for nearly twenty-five years, sought to inform and generate interest on the pleasures and involvement of canals and narrowboats to the community – not only in Rickmansworth, but far beyond as well. This has been achieved with interesting education programmes, hands-on learning experience for young adults, canal cruises on their own craft – the *Pride of Batchworth* – and the continuing conservation and presentation for operational use of the historic narrowboat *Roger*.

The trust also organises the Rickmansworth Festival, which attracts more than 20,000 visitors each year. The hub of all this activity is the Batchworth Lock Canal Centre, once a pub and stables but now housing a comprehensive shop providing a wealth of information and maps on everything connected with the waterway.

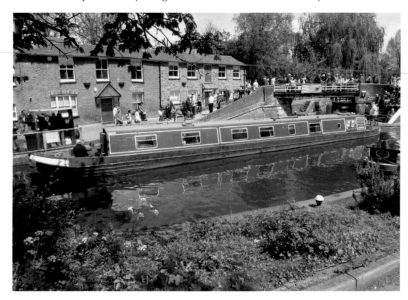

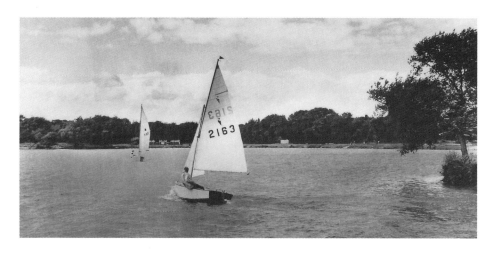

Rickmansworth Sailing Club/Bury Lake Young Mariners

It was eighty-five years ago, in early 1930, that the first seeds were sown by a small but dedicated group of sailing enthusiasts to form the Rickmansworth Sailing Club at Bury Lake, part of the Aquadrome complex. The club thrived but, after twenty-nine successful years, ultimately vacated the site in April 1959, moving to their new and much larger home, Troy Lake, situated a few miles away just off the main Rickmansworth/Denham road. In 1960, Hertfordshire County Council set up a school sailing base at Bury Lake, with HCC providing staffing and funding, but this support was withdrawn in 1982 due to public expenditure cuts.

It was then that the Bury Lake Young Mariners (BLYM) developed, aiming to promote the development of young people through the medium of sailing and related activities. With many fundraising initiatives, this has resulted in a high-quality fleet and comprehensive facilities ashore as this superb sailing club and the school goes from strength to strength. The club is now one of the largest all-voluntary clubs and training centres in the country.

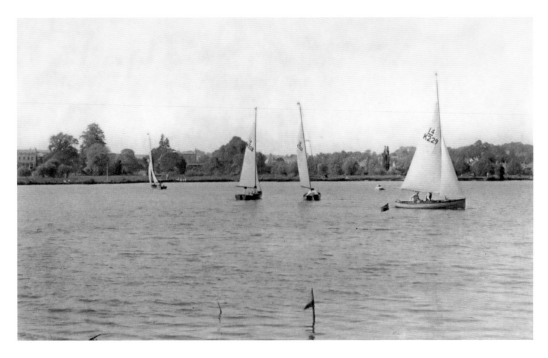

Chess Sailing Club

The Chess Sailing Club was formed in 1960 and, although not big, was very popular among the enthusiasts who sailed on Bury Lake each Sunday. In 1988, Chess amalgamated with Broadwater Sailing Club, transferring to their new venue at Broadwater Lake, next to Troy Lake and close to the Grand Union Canal. Below, an Enterprise Class boat similar to the craft owned by one of the key members of the club at that time, Christine Tollit, can be seen.

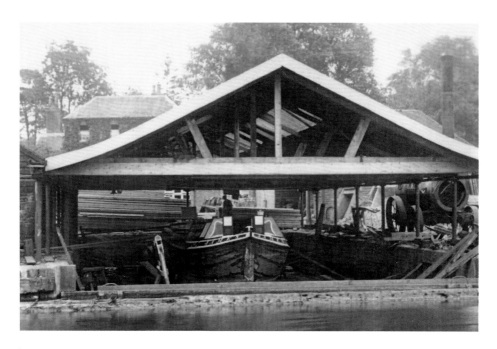

W. H. Walker & Brothers Ltd (1)

It was on Tuesday 6 June 1905 that young Harry Walker took over a lease on part of Frogmore Wharf on the Grand Junction Canal, Harefield Road, Rickmansworth, starting a successful business that would endure for the next eighty-four years. Not only were Walkers of Ricky (as they were known) builders' merchants, timber merchants and coal and coke merchants, they also had a fine reputation as boat builders, as can be seen in these two images – contributing greatly to the history of the inland waterway system.

The bottom picture shows the caulking of the seams to a Star Class motor boat in 1934. The first boats built were horse-drawn, but motor power was later introduced from 1913.

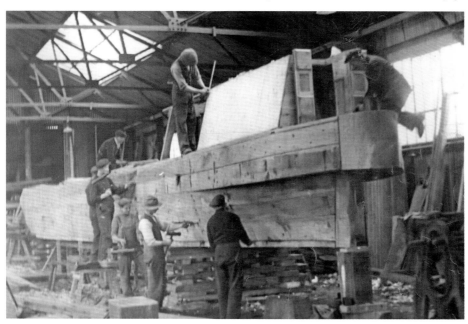

W. H. Walker & Brothers Ltd (2)

With boats for hire in the foreground, the steam launch *Gadfly* (below) belonging to Alfred Walker makes its way across Batchworth Lake towards Frogmoor Wharf, just visible in the distance. The photograph above depicts a motor boat moored at Frogmoor Wharf in the 1920s. All three lakes, Batchworth, Bury and Stocker's, were originally old gravel pits, some of the material allegedly being used in the construction of the original Wembley Stadium. In 1913, the Walkers purchased the freehold of Batchworth Lake for £3,600 from Lord Ebury for boating and pleasure activities, but fifteen years later an organisation called the Aquadrome Company bought both Batchworth and Bury lakes. The third lake, Stocker's, is a beautiful and peaceful location of approximately 100 acres, two-thirds of which is water with islands.

It is bounded on the south-east by the Grand Union Canal and on the north-west by the River Colne. It is owned by Affinity Water Ltd with the Friends of Stocker's Lake (FoSL), established in 1990 to conserve and enhance the area as a nature reserve. The natural beauty of the whole of this delightful place stands today as the jewel in Rickmansworth's crown.

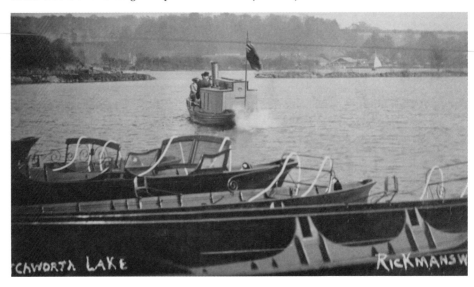

CHWORTλ LAKE RicKMANSW

W. H. WALKER
& BROTHERS LTD.

English and Foreign Timber Merchants

**BOAT AND BARGE BUILDERS - WOOD TURNERS
ROOFING AND FENCING CONTRACTORS
BUILDERS' MERCHANTS - COAL AND COKE**

Specialities:

SAND, GRAVEL, BALLAST, CEMENT, LIME
ASHES, CRAZY PAVING, ROCKERY STONE
DRAIN PIPES AND FITTINGS

Head Office and Sawmills:

FROGMOOR WHARF
HAREFIELD ROAD
RICKMANSWORTH

TELEPHONE 2271 & 2272

TIMBER SUPPLIED IN LARGE OR SMALL QUANTITIES
GARDEN SHEDS, GATES, RUSTIC POLES, WATTLE HURDLES, etc.

Branch Office:

STATION APPROACH, MET. RLY. STATION

W. H. Walker & Brothers Ltd (3)
Today, with narrowboats moored on the Grand Union Canal and Walkers of Ricky long gone, a Tesco supermarket now occupies the Frogmoor Wharf site, a sad day indeed for Rickmansworth when the firm closed in 1989.

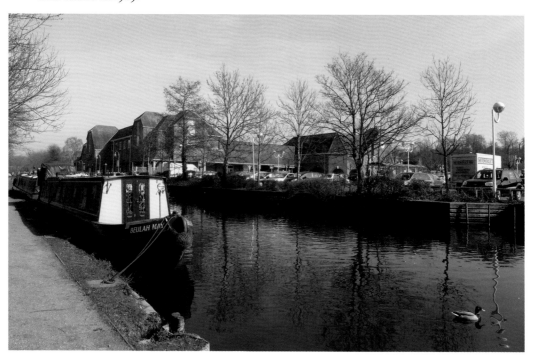

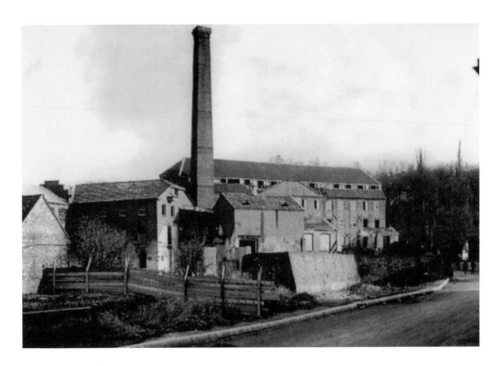

Batchworth Mill

Originally owned by Thomas Buller in 1759 for the weaving of cloth and silk, the mill was purchased in 1818 by John Dickinson, the manufacturing stationer, who took over the site for the production of half-stuff – the raw materials used to make the finished paper. When Batchworth Mill eventually closed, most of the buildings (except the one in the background on the extreme left as seen below) were demolished in 1910, but just before the chimney came down local photographer T. J. Price seized the opportunity to take some excellent pictures of the surrounding area from the top. The site was then purchased by the Rickmansworth & Uxbridge Valley Water Company for their new offices and pumping station. (Top picture courtesy of the Apsley Paper Trail)

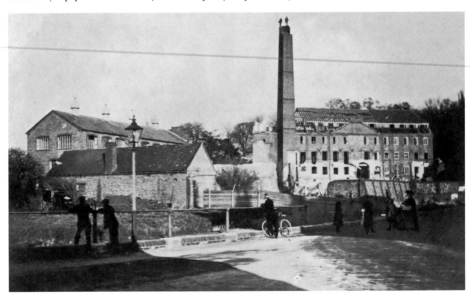

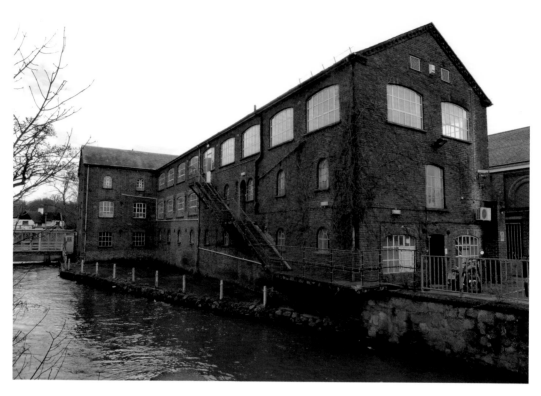

The Old Mill Building

These two photographs show the last remaining building of Batchworth Mill used by both Affinity Water, who now occupy the site as part of their sports and social club, and by the Batchworth Lock Canal Trust for education purposes.

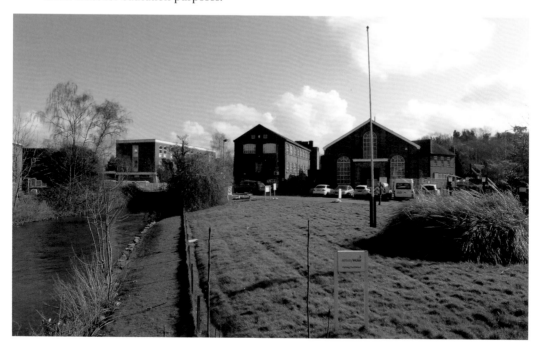

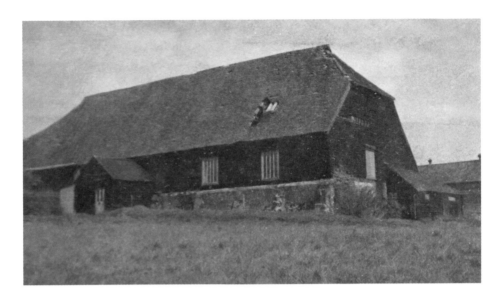

Croxley Great Barn

This magnificent Grade II-listed threshing barn, dendro-dated back to the winter of 1397/8, is one of the oldest and largest of its type in Hertfordshire, measuring 101 feet by 40 feet. The barn, which is now obscured by high hedges, is sited near to Croxleyhall Wood and Lot Mead Lock No. 80 and is a timber-framed, five-bay, aisled building with a crown-post roof – the doors within the porch were once large enough for a fully laden haywain to pass through over the 4-inch-thick oak flailing floor. In 1972, the ownership of the barn was transferred from Gonville and Caius College, Cambridge, to Hertfordshire County Council, who renovated it between 1972 and 1975. It was then leased to St Joan of Arc School until 1995, when the ownership was passed, at no cost, from the county council to the governors of the school. A further change of tenure took place in 2013, when the barn was transferred to a separate trust to avoid any financial liability to the school.

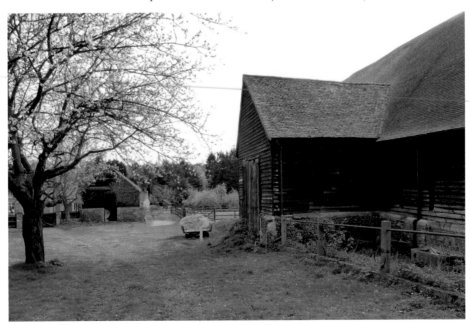

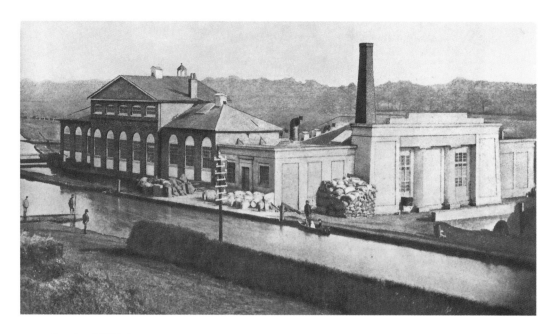

Croxley Mill (1)

Following the acquisition of sites for several of his paper mills, including Apsley, Nash and Home Park, John Dickinson (born 29 March 1782) turned his attention to Croxley, where a new mill opened in 1830. As Lord Ebury, who lived at nearby Moor Park, objected to the view that he had of the mill, Dickinson provided an Egyptian frontage, with two huge columns and an entablature of painted stucco that was more pleasing to the eye. With Croxley Mill long gone, the site is now occupied by the Byewaters housing estate.

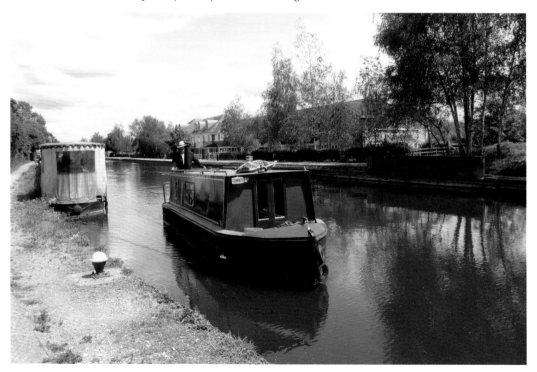

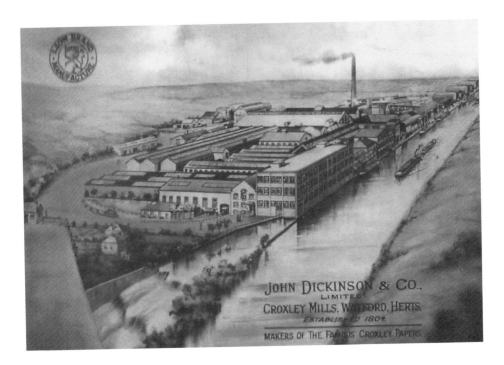

JOHN DICKINSON & CO.,
LIMITED
CROXLEY MILLS, WATFORD, HERTS.
ESTABLISHED 1804
MAKERS OF THE FAMOUS CROXLEY PAPERS

Croxley Mill (2)

The above early advertisement shows the fully established mill at Croxley. Building commenced in the autumn of 1828 with completion two years later in 1830. Production had barely started before a gang of machine breakers, men of the 'Swing Riots' – a widespread uprising by agricultural workers – marched on the mills on 29 November 1830 in the Gade Valley from Buckinghamshire. John Dickinson immediately organised a defence force for each of his mills under the command of General Beckworth, an old friend who was staying with him. Fortunately the rioters, still some way from Apsley, saw the red coats of the Old Berkeley Hunt in the distance, mistook them for mounted soldiers sent to defend the mills, and immediately turned back again. The picture also depicts the Grand Junction Canal, which was of vital importance before the coming of the railway for the transportation of incoming and outgoing materials and goods.

The modern-day photograph is looking towards Common Moor Lock No. 79 and Moor Park in the distance behind the tree line. (Top picture courtesy of the Apsley Paper Trail)

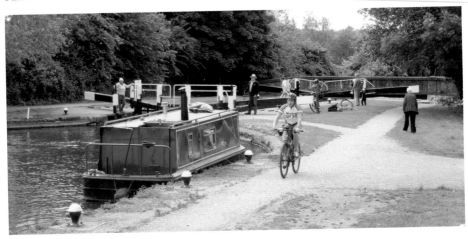

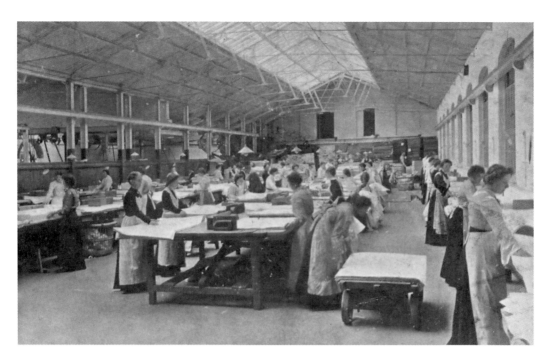

Croxley Mill (3)

The above postcard, which was sent on 26 May 1909, depicts the Paper Sorting House at Croxley Mill and appears to show all the hallmarks of a clean and well-organised working environment. The other card shows two working narrowboats, *Petrel* and *Moon*, tied up at the mill on the Grand Junction Canal waiting to unload their cargo of raw materials.

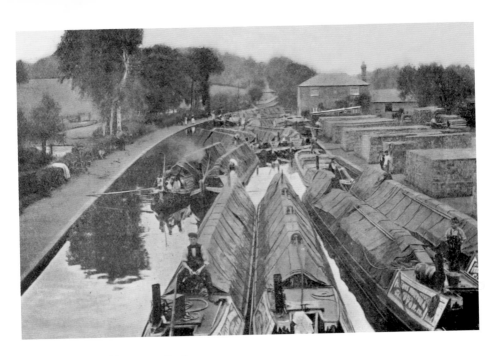

Cassio Wharf/Bridgewater Basin

This vibrant early photograph taken from Cassio Bridge shows a busy Cassio Wharf well before the construction of the Watford branch of London Underground's Metropolitan Line. Piles of bricks can be seen stacked on the wharfside, destined, in all probability, to local builders involved in the continuing development of Watford. Women and children can be seen to the rear of one boat as it was not uncommon for whole families to live and work on their craft, especially on long-distance routes. When one considers that the available living area was only 10 feet by the width of the boat, conditions were extremely cramped, to say the least.

Today, the wharf is Bridgewater Basin, owned by Reuben Carrdus – a member of the family that also owns Bridgewater Boats in Berkhamsted. The marina caters for the needs of boaters and their narrowboats, providing moorings, pump-outs, windlasses (lock keys), water, fuel and a host of other essentials for the dedicated canal enthusiast.

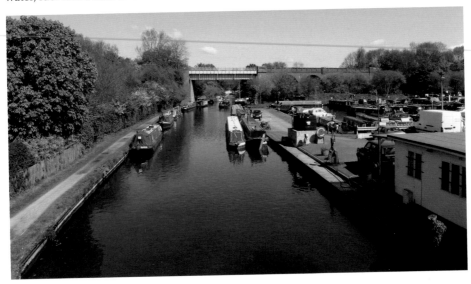

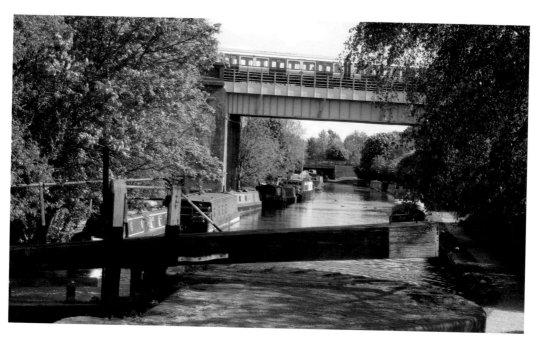

Cassio Bridge Lock

This tranquil scene taken from Cassio Bridge Lock No. 78 shows the canal back through the Metropolitan railway bridge towards Bridgewater Basin, with Cassio Bridge No. 169 in the distance. The train on the bridge appears to be a S8 Stock in its red, white and blue livery manufactured by Bombardier Transportation. These trains entered service from 31 July 2010. The 'S' designation stands for sub-surface and the '8' represents the number of cars (i.e. an eight-car train).

The image below, taken at Ironbridge Lock, is one of several narrowboats that ply the cut, providing a welcome and essential service to boaters with supplies of calor gas, fuel, diesel and other necessities. The sign at the rear of the boat indicates that they are 'Open for Trade'.

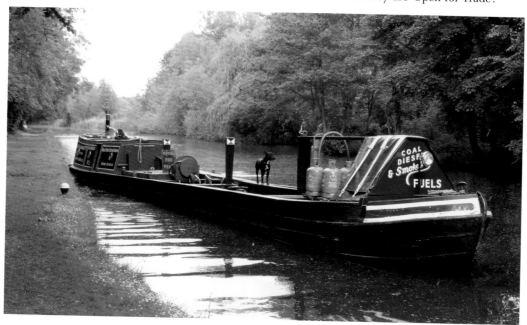

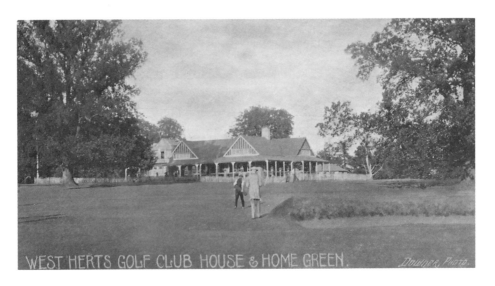

WEST HERTS GOLF CLUB HOUSE & HOME GREEN.

West Herts Golf Club

The prestigious West Herts Golf Club was originally formed on 24 March 1890 by thirteen enthusiasts living in and around the small village of Bushey, with play taking place in the grounds of Bushey Hydro, previously Bushey Hall, which was a large mansion. During the 1880s it was acquired by the Hydro Therapeutic Company, who converted it into a health establishment with various sporting activities, including golf, in the grounds. Following the termination of the lease at Bushey in March 1897, the club then took on the great undertaking of transferring to Cassiobury, where the annual rent of £250 had been agreed with the Earl of Essex. The first clubhouse in Watford was constructed in Rickmansworth Road on the site now occupied by Watford Grammar School for Boys. As the course was on both sides of the Grand Junction Canal, a bridge, known as the Golfers' Bridge, was built over the canal in 1897.

Boaters in passing narrowboats were often shocked by the richness of the golfers' vocabulary, probably due to an air shot where the stroke had missed the ball entirely. Today the clubhouse, as seen below, is based in Rousebarn Lane, with its superb course now contained along the west side of the canal. (Top picture courtesy of David Huggins)

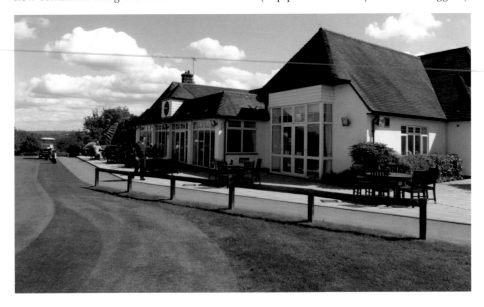

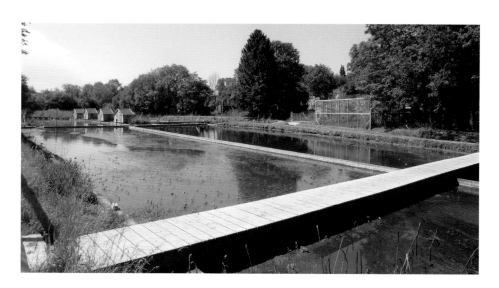

Cassiobury Farm & Fisheries

Located adjacent to the canal, near Rousebarn Lane Bridge No. 168, is one of the most exciting modern canalside industries to thrive in the area today. A 15-acre site, including 3 acres of lake, was purchased by the present owner in 2006, whose lifelong ambition was to run an open working farm and to keep exotic animals. In 1820 the land had been cultivated into watercress beds, the production of which continued up to the 1940s/50s.

At one stage, the Watford Piscators fished in the lake. The land is now managed by a dedicated team of three full-time staff and two part-time, with their hours being spent on building, maintenance, feeding the animals and taking enormous care of the more exotic animals, which include squirrel monkeys, alpacas, giant pelicans, European storks and sulcata tortoises – to name but a few. The open farm hopes to sell a variety of eggs from the ducks, chickens, geese and quails kept on the land. Watercress has started to be planted again, together with water mint. This fascinating and most interesting site plans to hold six open days a year. The pictures show the new watercress beds and one of the squirrel monkeys.

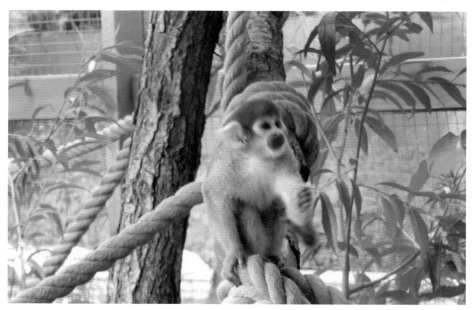

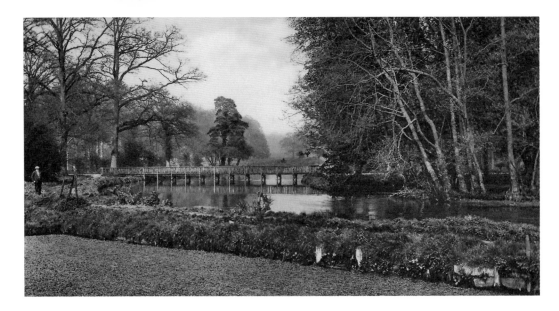

The Watercress Industry

Since commercial watercress growing was introduced into Hertfordshire at West Hyde in 1815 by William Bradbury, the county has been at the forefront of watercress production due to the ideal conditions of broad valleys with good light and water which arises from the chalk aquifer at a constant 11 degrees centigrade all year round. The main producers in the area were the Penney family, three generations of whom had grown watercress in Cassiobury Park until the retirement of Bill Penney in 1990. Croxley was also a key area, where the Sansoms of Croxley Hall Farm had pioneered the plant during the latter part of the nineteenth century. The Sansoms continued growing watercress until about 1990, when the business switched over to trout fishing and farming.

The above picture shows the watercress beds in Cassiobury Park, Watford in their heyday, with the bottom image depicting the old beds situated behind the tree line on the left-hand side, now overgrown and tangled – the remnants of a once thriving industry.

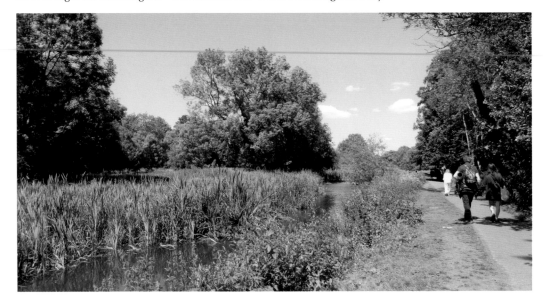

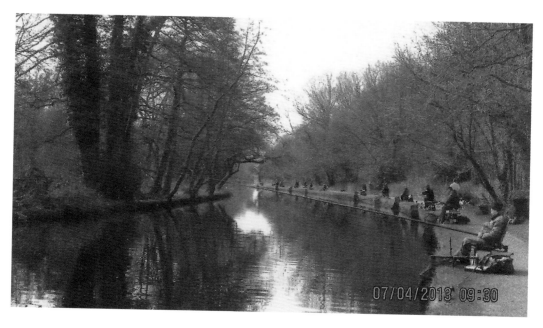

Watford Piscators

Watford Piscators was founded sometime prior to 1885, but was first recorded that year by *Fishing Gazette* magazine. The club was devoted to the gentle art of fly fishing, mainly on the rivers Gade and Colne where, at the latter, it was recorded that twelve anglers caught a total of forty-six trout in one day. How things have changed. Watford Piscators currently leases a stretch of waterway from Batchworth Lock No. 81 at Rickmansworth to Bridge No. 166 near the Grove from the Canal & River Trust, although the first angling agreement was taken out with British Waterways in the early 1920s. The anglers seen in the two pictures are fishing north of Ironbridge Lock No. 77 in what is known as a 'pound' – the stretch of water between locks. This particular pound is known as Park Pound. (Pictures courtesy of Peter Hadwin)

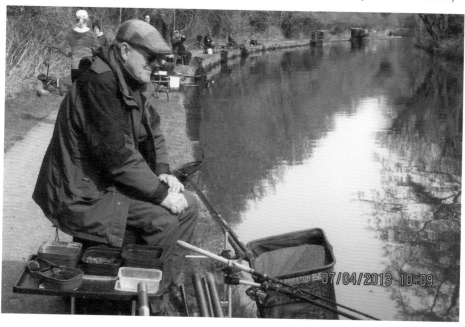

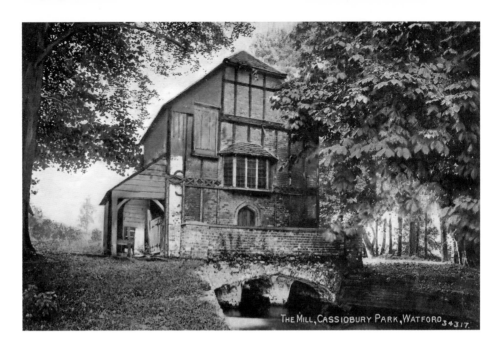

The Mill, Cassiobury Park, Watford 34317

The Old Mill, Cassiobury Park

Hidden among the trees next to the weir at the bottom of Cassiobury Park and adjacent to the canal is the site of the Old Mill, once used to grind corn and later utilised for the pumping of water to Cassiobury House. Following the demolition of the mansion in 1927, the mill fell into a state of disrepair and in 1956 was eventually knocked down and removed, although after nearly sixty years there are still signs of this historic structure to be seen.

In the early spring, before the foliage and undergrowth start to grow, some of the foundations are just visible from the opposite river bank. The brick arches over the mill stream, as seen below, are even now very much in evidence – a small remnant of a bygone age.

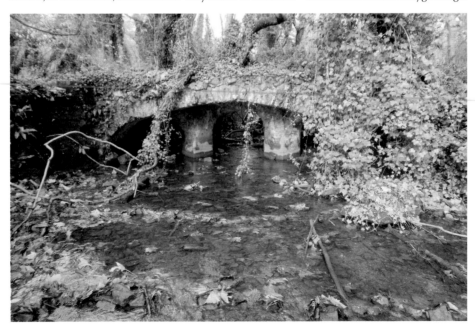

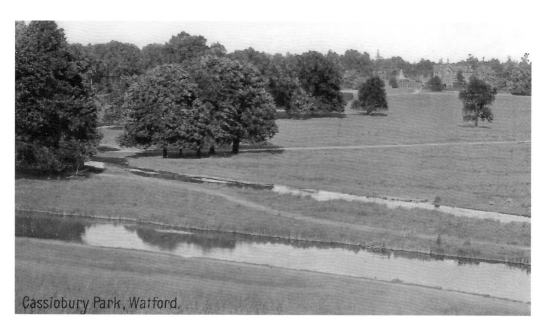

Cassiobury Park, Watford.

Cassiobury House, Watford

Pictured below in the early 1900s, it is difficult to imagine that twenty-five years later this magnificent mansion, Cassiobury House, seat of the Earls of Essex, would be no more. Situated near Temple Close and the tennis courts on what was once the Cassiobury Estate, the house had been built and rebuilt several times since its original construction was commenced by Sir Richard Morrison in the mid-sixteenth century.

Following the death in 1916 of George Devereux de Vere Capell, the 7th Earl of Essex, his wife Adele, the Countess Dowager of Essex, sold the estate in 1922. With no purchaser for the house, it was left empty and derelict for a further five years until its demolition in 1927. As was to be expected, there was a considerable amount of building materials to be disposed of and this was sold by auction on site on Wednesday 9 November 1927 – the end of an era. The above picture postcard shows the house in the distance with the River Gade and the canal in the foreground. (Top picture courtesy of David Huggins)

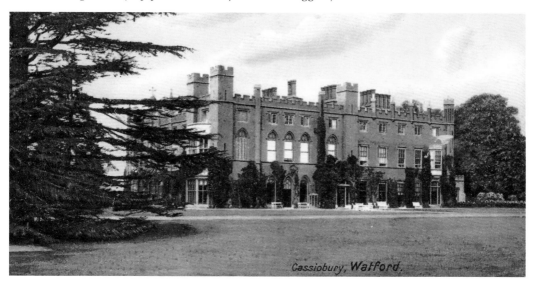

Cassiobury, Watford.

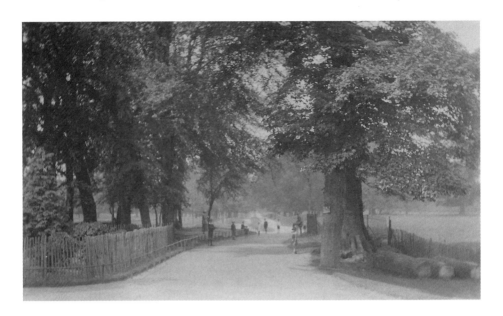

Cassiobury Park (1)

Intrigued by the presence of the photographer, these young people appear to be enjoying a stroll at the Rickmansworth Road end of Cassiobury Park, probably accompanied by the two adults shown near the fencing. At the turn of the nineteenth century, with the 7th Earl of Essex now living in London and despite considerable public feeling, 65 acres of this beautiful parkland were purchased in 1909 by Watford Urban District Council for the purpose of 'public walks and pleasure grounds', with a further 25½ acres being acquired three years later.

Today, the award-winning park attracts numerous visitors from far and wide. They come to enjoy the many amenities on offer and to stroll along the tree-lined avenues, just as those young people in the above photograph did over a hundred years ago. The picture below shows the children's paddling pool, constructed in 1933, and the River Gade. Captured during the long, summer days of the 1960s.

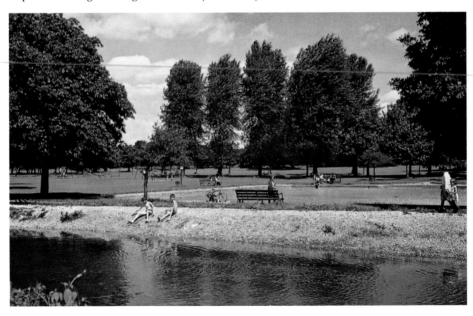

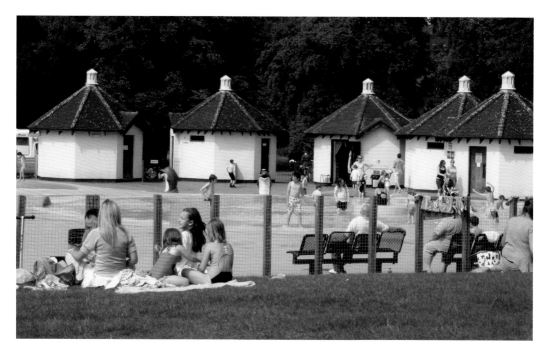

Cassiobury Park (2)

Today this beautiful park, once the estate of the Earls of Essex, comprises 190 acres of open grass and woodland, including a designated wildlife and nature reserve managed by the Herts & Middlesex Wildlife Trust. Some of the old watercress beds in the park have now been developed into marshland. With two of the popular attractions on offer featured above and below, and with the Grand Union Canal and the River Gade close by, it is no wonder that this lovely award-winning park draws thousands of visitors from far and wide each year.

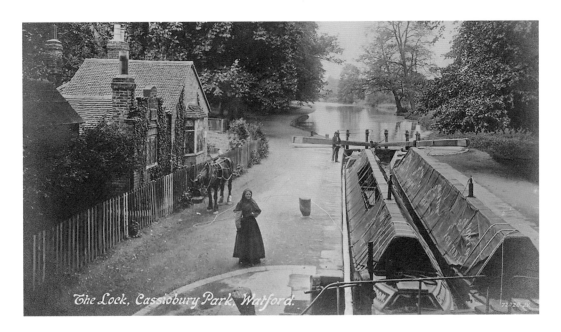

The Lock, Cassiobury Park, Watford.

Ironbridge Lock No. 77

The tow horse is obviously enjoying his nosebag of feed and a well-earned rest in this charming postcard sent on 24 July 1913. Originally known as the Grand Junction Canal and part of the waterway system connecting London and Birmingham, the company was bought by the Regent's Canal in 1927 before amalgamating with several other companies to form the Grand Union Canal in 1929. Whereas once the narrowboat was used solely to transport coal and other commodities, today's modern craft – such as those seen in Cassiobury Park's Ironbridge Lock No. 77 – attract numerous people each year for holidays and weekend breaks. Although the cottage has now gone, the area is nevertheless one of the most picturesque parts of the waterway, always attracting 'gonggoozlers' (those who stand idly about, especially at locks, watching the activity) to see the craft pass through.

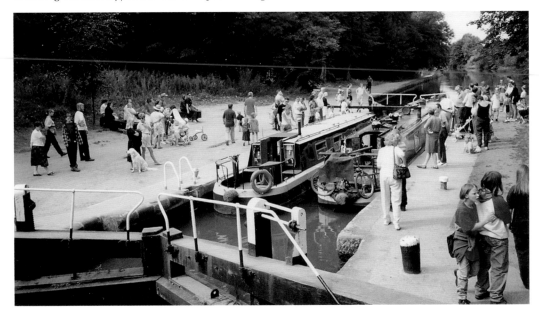

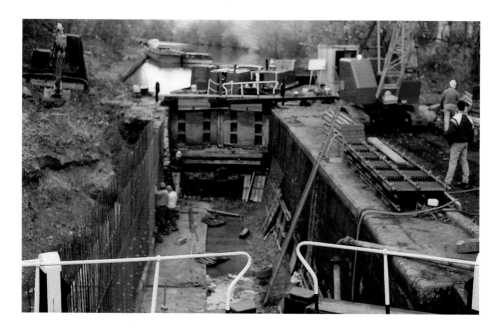

Ironbridge Lock No. 77 Remedial Works

During the summer of 1991, the towpath side of the lock wall became extremely unstable. In order to keep the navigation open during the boating period, the structure was stabilised in the short term with the lock wall rebuild scheduled for November of that year. The works consisted of removing the old brickwork and replacing it with a steel-reinforced concrete wall, with the job carried out over a seven-week period. Further work was carried out early in 2015, as seen below, when the top lock gates were replaced after twenty-five years of service, having come to the end of their useful life. The new made-to-measure gates, each weighing several tonnes, are handcrafted from seasoned oak so that a perfect fit in the lock chamber is ensured. It is hoped that the new lock gates will be in place for a further quarter of a century, helping the Canal & River Trust to conserve water. (Pictures courtesy of John & Cynthia Morgan)

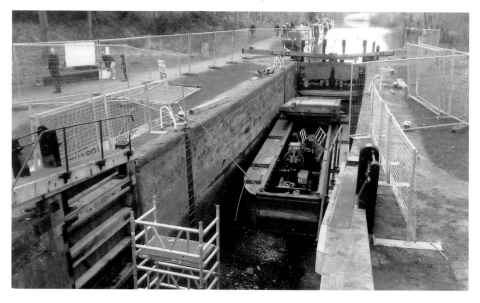

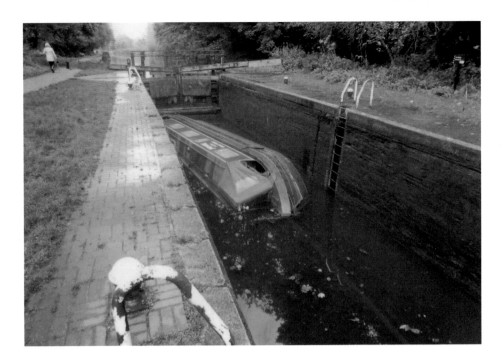

Capsized Narrowboat

Despite the many warning signs indicated at locks along the waterway system to 'Keep boat forward of cill marker', it would appear for one unfortunate boater that in this instance it did not happen. It was in October 2014 that a narrowboat passing into Ironbridge Lock No. 77 flipped on its side and sank. The initial investigation indicated that the accident was allegedly due to 'boater error'. Although fortunately no one was injured, the owner was making arrangements for the craft to be winched out. Until that took place, no other boats could pass through until the operation had been completed. The cill (or sill) is the solid ledge, usually of concrete or concrete and wood, against which the bottom edges of the lock gates close. (Top picture courtesy of John & Cynthia Morgan)

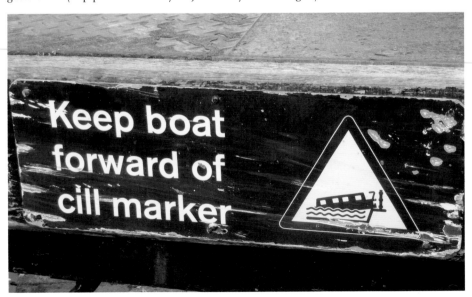

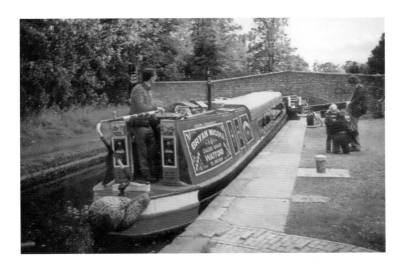

Arcturus

The Star Class historic motor narrowboat *Arcturus* and its butty *Sirius* were built by W. H. Walker & Brothers of Rickmansworth in October 1934, and were the first pair delivered to the Grand Union Canal Carrying Company Ltd. They represented the company at the royal opening of the New Wide Locks by the Duke of Kent at Hatton Top Lock on 30 October 1934. They remained with GUCCCo until *Arcturus* was sold to A. Wander Ltd, the Ovaltine factory at Kings Langley, to form part of their fleet in August 1942. By September 1957, *Arcturus* was to be seen carrying coal down to the Royal Porcelain works in Worcester, while *Sirius* was also observed being used as a maintenance boat on the Llangollen Canal.

Bryan Nicoll, a keen narrowboat enthusiast, purchased *Arcturus* in December 1958 and, following repairs and conversion, started a passenger-carrying service – first in Guildford in the summer of 1959 and then for a short period in Berkhamsted in 1965, before running trips from Ironbridge Lock No. 77 in Cassiobury Park from 1966 until October 1999, when both owner and boat retired.

Arcturus and *Sirius* were taken to the reopening celebrations of Blisworth Tunnel in 2005 and are currently moored at Puttenham on the Aylesbury Branch. Bryan is seen above at Ironbridge Lock No. 77 and below, just beyond Grove Mill Lane Bridge No. 165. (Top picture courtesy of David Huggins)

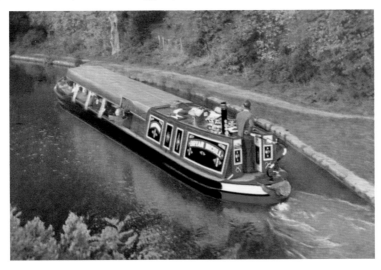

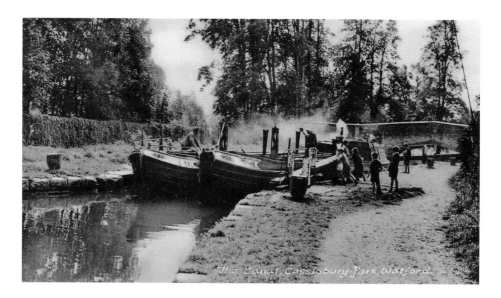

Puddling

This peaceful scene has barely changed in the eighty-or-so years that separate these two images taken at Ironbridge Lock No. 77, where inquisitive youngsters are always ready to give a helping hand. A frequently asked question by children throughout the generations, and indeed by many adults too, is 'why doesn't the water in the canal soak away?'. To find the answer, we have to travel back in time to when the canal system was being constructed in the eighteenth century by the large gangs of navigators, or navvies as they are known today – so called because they were building waterways for boats.

A process known as 'puddling' developed by the early canal engineer, James Brindley, was used. Mixed clay and water was spread up to 3 feet thick to line the bed underneath a layer of ordinary soil. Very often the clay and water was made into puddle by navigators treading it down for hour after hour.

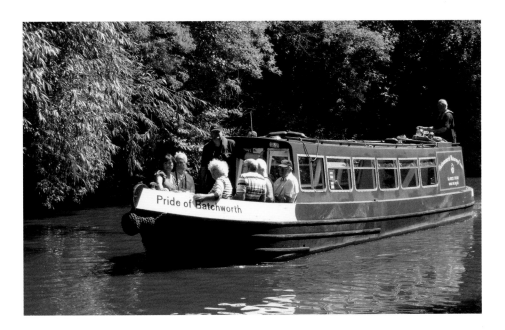

IWA National Festival 2013, Cassiobury Park

The Inland Waterways Association's National Festival 2013 was held on the Grand Union Canal in Cassiobury Park, where the three-day event over the weekend of 19–21 July, an annual celebration of the nation's waterway system, attracted up to 30,000 visitors. With hundreds of narrowboats gathered from all over the country, the exciting extravaganza of crafts, entertainment, canal cruises and activities to suit all tastes was guaranteed to be a huge success. The *Pride of Batchworth*, seen above taking a party of visitors on a short cruise, was built in steel by Sherborne Street Wharf of Birmingham in 1989 as an electric (battery) powered trip boat for use on the Birmingham Canal Navigations.

The boat is 38 feet long, 6 feet 10 inches wide and is licensed to carry a maximum of twelve passengers with two crew under the auspices of the Small Passenger Boat Code. This elegant craft was acquired by Rickmansworth Waterways Trust in 2004 and is moored at the Canal Centre, Batchworth Lock No. 81. Below, some of the narrowboats that have gathered for the festival, all proudly flaunting colourful decorations of flags and bunting.

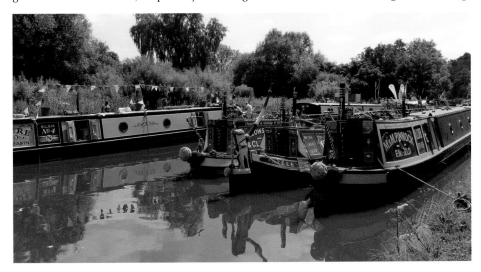

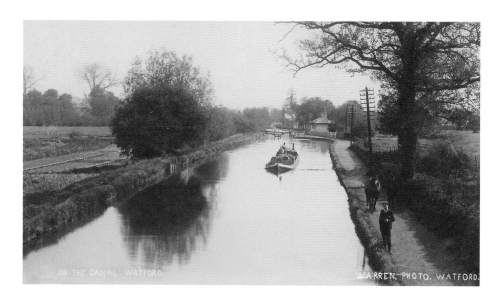

Lock Nos. 75 & 76

A gradually disappearing way of life is depicted here in this old postcard of a working narrowboat travelling along the cut, as the canal is sometimes called, near Watford. With steam and diesel replacing the tow horse in the early 1900s, it was possible to carry extra cargo by towing a second unpowered boat, called a 'butty'. Along the towpath towards Grove Mill, in close proximity to each other, are Lock Nos 75 and 76, known as 'Albert's Two' on account of one Albert Evans, who was the lock keeper there for a great many years in the 1930s. The modern image of the pretty nineteenth-century lock keeper's cottage portrays a peaceful way of life that today is just a memory, and although there are no essential utility services, with water obtained from a well, this must surely be one of the most idyllic spots locally in which to live. With more and more people seeking an active yet tranquil way of spending their retirement the name of the narrowboat entering Lock No. 76, *Ternstaw*, tells it all as the word is an anagram for 'New Start'.

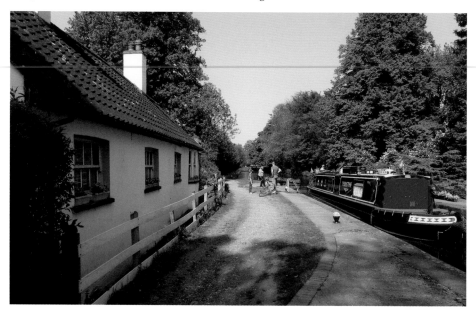

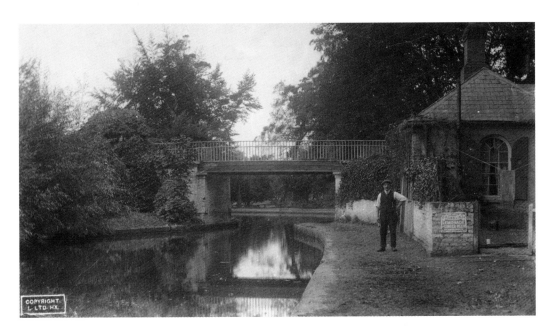

Grove Mill Bridge No. 165

This charming waterside dwelling adjacent to Grove Mill Bridge No. 165 in Grove Mill Lane, called Canal Cottage, was built in the early nineteenth century by the Grand Junction Canal Company as accommodation for one of their employees, whose job it was to collect tolls from passing narrowboats, and to ensure that there was an adequate supply of water to the nearby Grove Mill. From circa 1910 to 1930 the cottage was occupied by Fred and Rosa Tearle and their two children, and at one stage Rosa ran the premises as a small tearoom, certainly a lovely setting to sit and enjoy a cool, refreshing drink. The sign on the garden wall of the cottage advertises the sale of 'Franklin's Lemonade and Ginger Beer'.

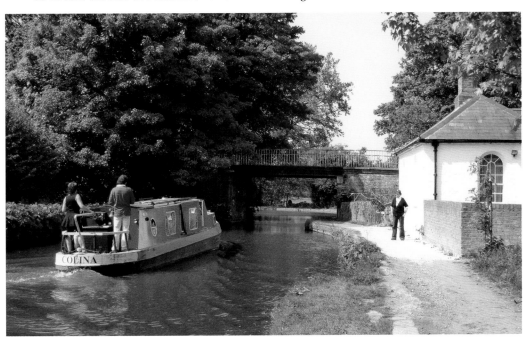

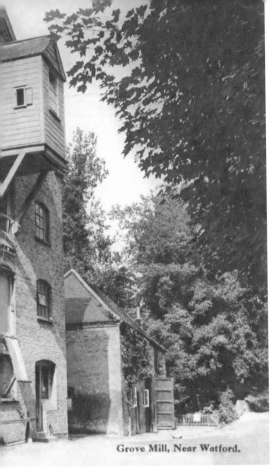

Grove Mill, Near Watford.

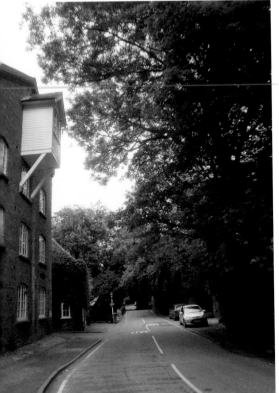

Grove Mill (1)

Apart from the two cars in the picture below, little change appears to have taken place in this delightful scene at the bottom of Grove Mill Lane, where time has almost literally stood still. The focal point of this quiet setting was Grove Mill, built in 1875 to produce flour for the Grove Estate. This was the family seat of the Earls of Clarendon, with the miller and his millhands living in the adjoining house and cottages. The small wooden structure attached to the top level of the mill was known as a lucum, or sack hoist, where the newly delivered bags of corn were lifted by chain from the cart below. Once the flour had been ground, the reverse process would take place with the sacks being lowered onto the waiting transport for delivery to the estate. Opposite the mill is the dower house, built by the Earl of Clarendon for his mother, the dowager Countess of Clarendon.

One of the previous owners of this lovely building was Fanny Cradock, the renowned television cook and writer who, together with her partner and later husband Johnnie, dominated the small screen throughout the 1950s and 1960s with her cookery demonstrations. Following a long period of disuse when the old mill fell into a state of disrepair, it eventually underwent a complete renovation and was tastefully converted into flats during the early 1970s.

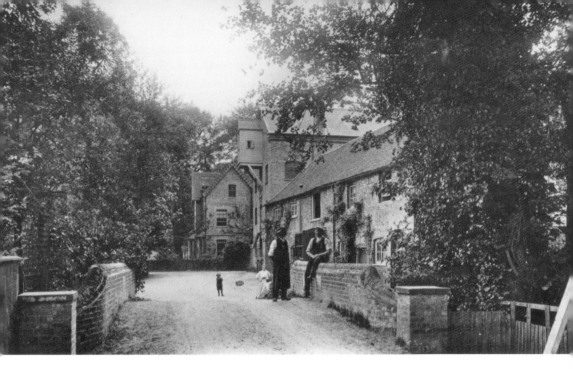

Grove Mill (2)
Another lovely view of the old mill is depicted above, with the photograph below showing the weir that controlled the flow of water to the mill. Grove Mill Bridge No. 165 is just round the bend in the canal behind the trees.

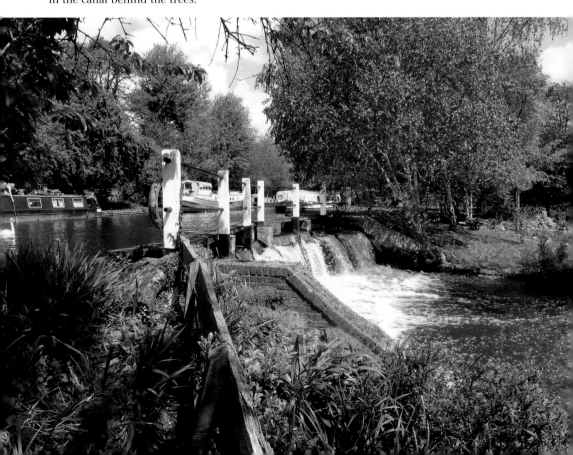

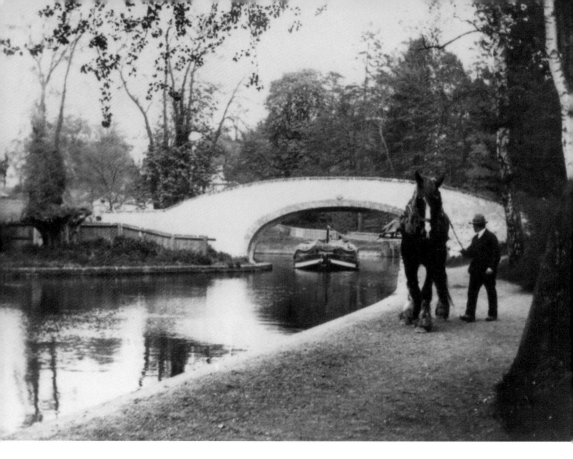

Lady Capel's Wharf

The above illustration shows a horse-drawn wide boat at Lady Capel's Wharf, just north of Watford, in 1916. Although nothing remains today, it was here, just off the Hempstead Road, that the wharf was built, due to Watford being the closest point to the Port of London, where coal could be offloaded from the canal without having to pay a coal tax. This was due to a monopoly enforced by the Grand Junction Canal Act of 1793 that prohibited coal from the collieries of Warwickshire, Leicestershire and Staffordshire being conveyed any further south without payment of the duty. The coal offloaded at the wharf then continued its journey by horse and cart. In 1861, the area for the coal duty was changed to coincide with the Metropolitan Police District, with the boundary for the collection of coal taxes being transferred to Stocker's Lock No. 82 at Rickmansworth. Coal duty was eventually abolished in 1890. (Above picture courtesy of David Spain)

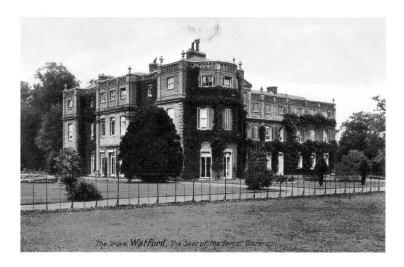

The Grove, Watford, The Seat of the Earl of Clarendon.

The Grove

Formerly the palatial home of the Earls of Clarendon, this early twentieth-century card of the Grove was posted on 12 August 1915. Situated in 300 acres of fine parkland and woods, the house is believed to have been built in 1756 by Sir Robert Taylor, although some sources suggest this could have been earlier. When the estate was acquired by Lord Doneraile in 1743, part of the work carried out involved the conversion of an ancient chapel into a kitchen. Legend has it that as a punishment for this heinous act, Lord Doneraile was condemned, on his death, to spend the hereafter riding through the extensive grounds on a phantom horse, accompanied by an equally intangible pack of hounds in pursuit of a ghostly fox, a spectral scene claimed to have been witnessed by many of the estate workers.

Following the Earl of Clarendon's move to his London home in the early 1920s and the subsequent sale of the estate in 1936, the Grove has passed through several hands, including a high-class girls' school, where the inclusive fees were described as '35 to 45 guineas a term according to age'. British Rail used the building as a training centre and today it enjoys a new renaissance as a luxury hotel, spa and golf resort. (Painting below courtesy of Prue King)

The Grove, Watford 2000

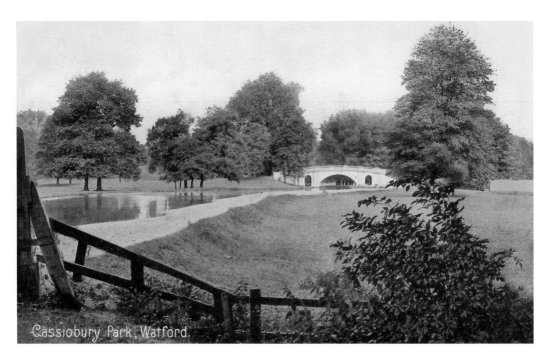

Cassiobury Park, Watford.

Grove Ornamental Bridge No. 164

Straddling the Grand Union Canal in one of the most beautiful stretches of waterway, this lovely early nineteenth-century white stuccoed bridge, with its distinctive arches on either side, carries the approach drive to the Grove from the main entrance in Hempstead Road. Situated in the picturesque countryside of the Earl of Clarendon's estate, the scene has barely changed in the hundred-plus years that elapsed between these two charming images being taken.

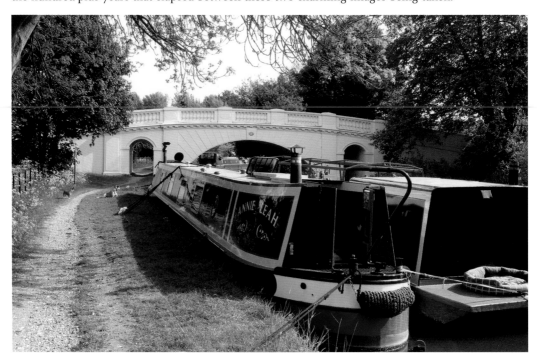

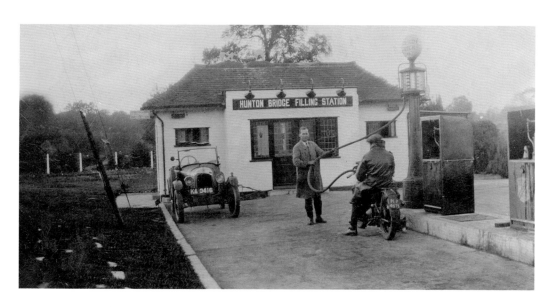

Hunton Bridge Filling Station

This delightful old photograph, probably from the mid-1920s, shows the Hunton Bridge Filling Station at a time when the pace of life was more tranquil and traffic-free than it is today and the price of petrol was only about 1s 5d a gallon. Situated next to the canal where Old Mill Road, just to the right of the garage, meets the A41, the petrol station has changed out of all recognition when compared to the earlier image, which is only to be expected after almost ninety years.

The car is a Citroen C2 known in France as the Trefle (Cloverleaf), also commonly known as a 5CV and was produced between 1922 and 1926. It may well have been one of the original models to be produced at Citroen's first overseas factory in Slough. It is interesting to see that the attendant, no doubt justifiably proud, is using one of the new Fry 'guaranteed visible measure petrol pumps', where the amount of fuel selected filled a transparent glass bowl. The motorist could then check to see that the number of gallons being dispensed and the particular grade, denoted by the colour of the petrol, was what had been requested.

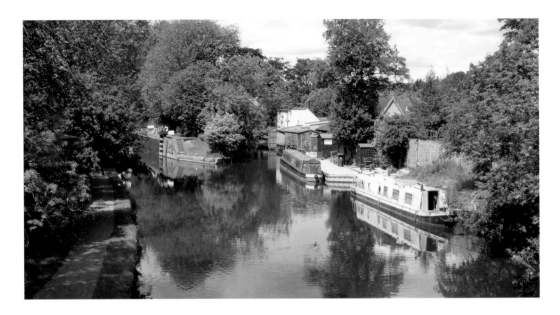

South West Herts Narrowboat Project

In 1987, an enthusiastic group of volunteers formed the South West Herts Narrowboat Project, an independent UK charity with the aim of providing narrowboat facilities to local youth and community groups. Based on the River Gade where it meets the Grand Union Canal at Hunton Bridge, this superb inland waterways charity has for nearly thirty years gone from strength to strength, giving numerous young people and the community at large the opportunity to participate in the wide range of activities associated with narrowboats and the canal, which they otherwise would never have had, thus generating a lifetime of interest and involvement. The charity has two narrowboats: *Dick's Folly* was officially launched in May 1989, and their latest addition, the 60-feet-long *Pickle's Folly* arrived at Hunton Bridge in March 2013, with both boats being fully equipped to an exceptionally high standard.

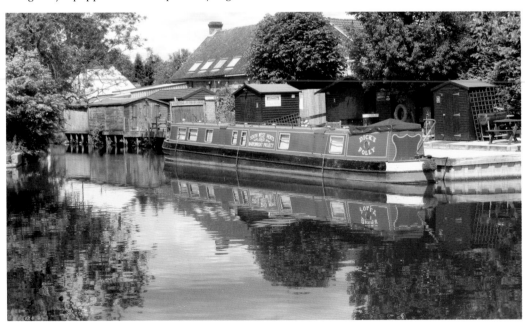

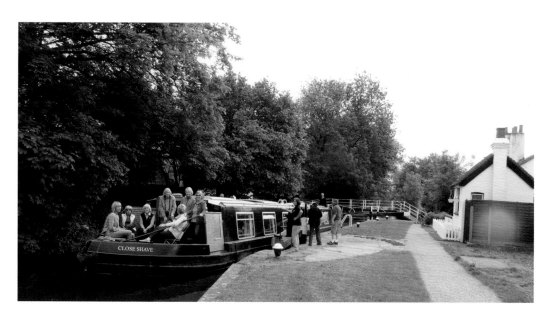

Waterways Experiences

Another pleasure boat business providing day, half-day and summer evening trips is the excellent Waterways Experiences. This popular boating firm, based at Nash Mills, Kings Langley, and advocating 'Accessible canal boating for all' was formed in the late 1990s, and is run totally by a team of dedicated volunteers. They have three wide-beam narrowboats, all 65 feet long: *Close Shave*, *Sheldrake II* and *Sheldrake III*, each with comprehensive onboard facilities. The photograph above shows a group of ladies at Hunton Bridge Lock No. 72 thoroughly enjoying their day trip out, with the photographer catching them up again later at Home Park Lock No. 70.

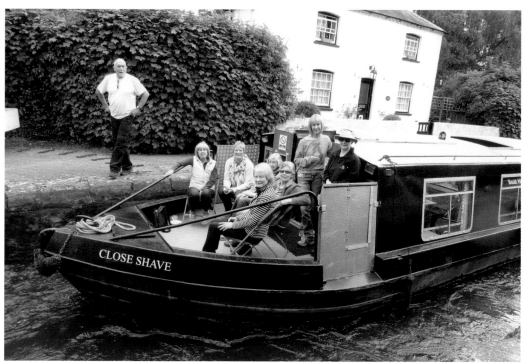

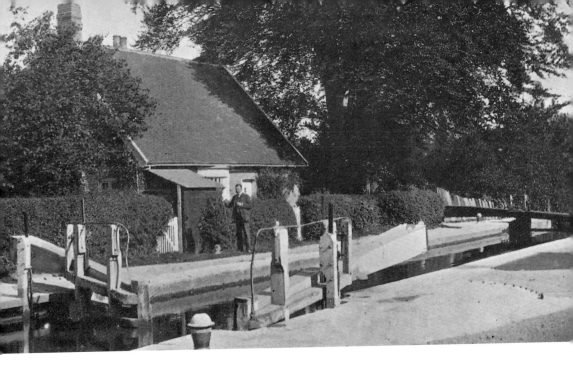

Lock No. 72, Hunton Bridge (1)

Time seems to have stood still in this lovely vista when comparing these two pictures of Lock No. 72 showing the old lock keeper's cottage – still occupied, but now under private ownership. Local directories indicate that the lock keeper from around 1935 to 1952, possibly a little longer, was one Charles Goodman.

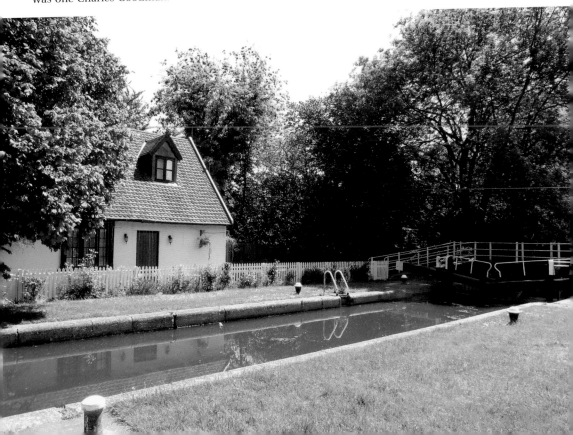

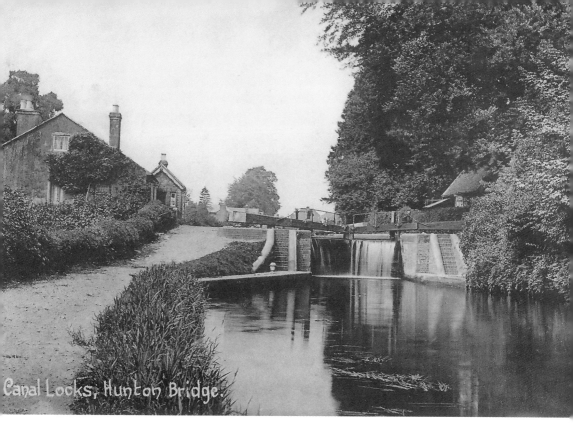

Canal Locks, Hunton Bridge.

Lock No 72, Hunton Bridge (2)

Two attractive views of Lock No. 72 are illustrated here, photographed in the early part of the twentieth century and, although the scene has considerably matured in the intervening years, it is nevertheless a peaceful place to pause for a while and watch the narrowboats pass through the lock.

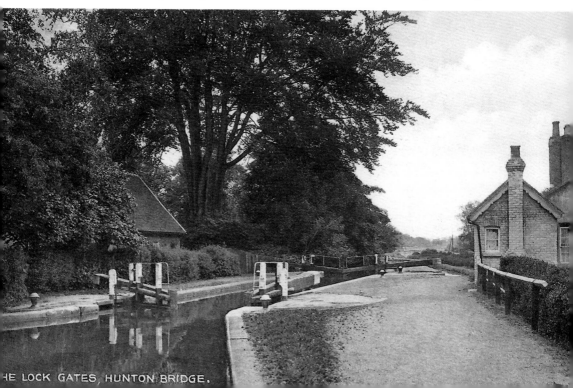

THE LOCK GATES, HUNTON BRIDGE.

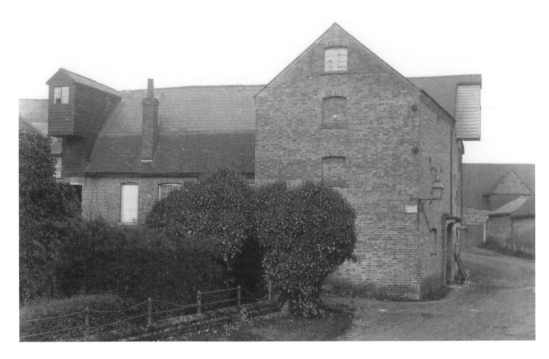

Hunton Bridge Mill

This large, rural water mill at Hunton Bridge on the Grand Junction Canal was, in 1544, owned by Sir Richard Lee and was originally constructed to harness the power of the River Gade. For nearly thirty years, between 1826 and 1855, the miller was one John Carpenter, with the Puttnams running two mills in the 1920s – Hunton Bridge and Grove Mill. During the Second World War, Hunton Bridge Mill was used as a small munitions factory, but after the cessation of hostilities it was demolished, probably due to road improvements on a blind bend in Old Mill Road. Although in an inoperative state, the waterwheel still survives. With a diameter of approximately 10 feet and a width of 13 feet, this overshot wheel of five bays has an estimated total of 200 buckets. All that remains today is the mill stream from the canal (below), the waterwheel (inset), and an impressive 200-year-old mill house. (Top picture courtesy of David Spain)

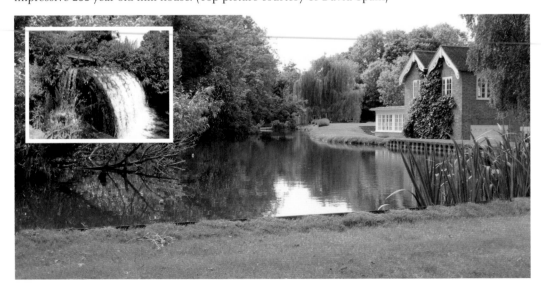

Hunton Bridge

Bridge Road Canal Bridge No. 162

Following repairs in 1902, the canal bridge was completely rebuilt in 1904. Like most of this stretch of inland waterway in south-west Hertfordshire, there are many pretty walks along the towpath, as seen in the view below taken on a fine, sunny summer's day. The above image is a lovely pen-and-ink drawing overlaid with a watercolour wash by a local artist, and shows a picturesque scene from the other side of the bridge. (Painting courtesy of Prue King)

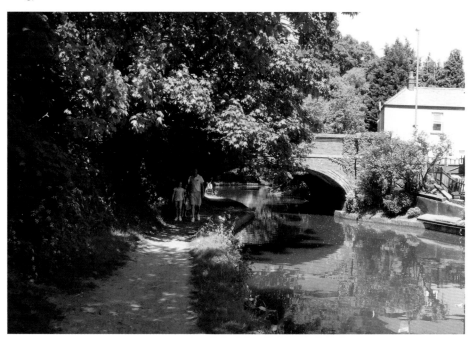

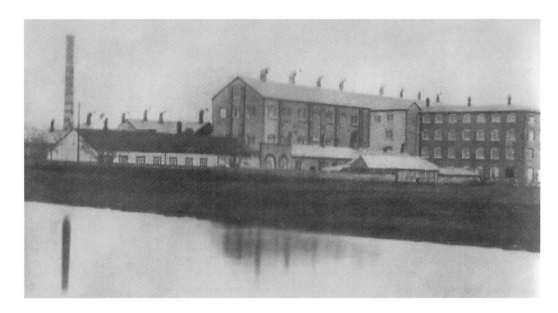

Home Park Mill, Kings Langley

On land purchased from the Earl of Essex, building commenced on another John Dickinson mill, this time at Home Park – a name suggested by Lord Essex to perpetuate the title borne by the land when it had been granted by Edward IV to his ancestors, it having originally formed part of the park of the royal palace built by Henry III at Kings Langley. With the first brick being laid by Dickinson's five-year-old son Samuel on 20 June 1825, the mill eventually started production a year later on 28 July 1826 with the manufacture of card and paper on three machines. By 1837, Home Park was producing 910 reams a week. Today, with the wharves and factory gone, modern offices and apartment blocks now occupy this pleasant canalside site. (Top picture courtesy of the Apsley Paper Trail)

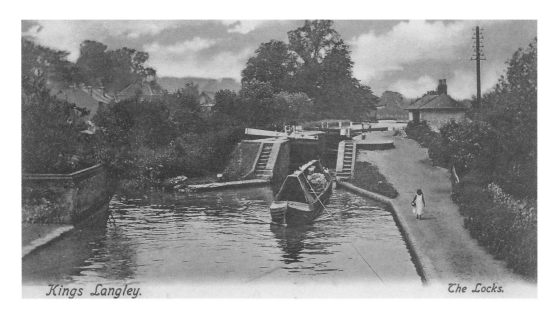

Kings Langley. *The Locks.*

Lock No. 69A, Kings Langley

A major problem over water supplies near Hemel Hempstead involved several millers, including John Dickinson, during the early part of the nineteenth century. At Two Waters, the Grand Junction Canal is joined by both the rivers Bulbourne and Gade. Further downstream from this merging point, the canal ran for 1½ miles on the level, without a lock, before dropping down 28 feet through a flight of four locks to the Kings Langley pound. As this alignment reduced the flow of water to John Dickinson's Apsley and Nash mills, Dickinson suggested that the whole line of the canal should be diverted to follow the course of the River Gade.

An Act was drawn up for submission to Parliament authorising the closure of the canal from Frogmore to the tail of the four Kings Langley locks, and the construction of the new line along the river. The diversion opened in March 1819, restoring power to the two mills and providing them with canal transportation. The flight of four locks had now been replaced by five new ones. Today little remains of the original line, but, to avoid renumbering the locks southwards from Braunston, Kings Langley Lock No. 69 became Lock No. 69A.

59

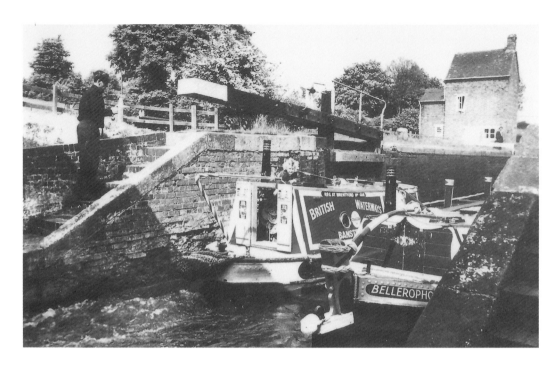

The Bargee

In 1964, a comedy film was distributed by the legendary writing duo Ray Galton and Alan Simpson. The film was *The Bargee*, starring a cluster of iconic British TV and film comedians including Harry H. Corbett, Ronnie Barker and Eric Sykes, to name but a few. Harry H. Corbett, a narrowboat trader, plays a notorious Casanova of the canals with 'a girl at every lock'. The two narrowboats featured in the film were the motor *Banstead* and its butty *Bellerophon*, pictured above near Braunston. Both boats were built by Harland & Wolff Ltd at Woolwich in 1936 and 1935 respectively.

Recently, Banstead was sighted at the 2015 Rickmansworth Festival, and later seen moored, below, along the canal at Kings Langley. (Top picture courtesy of the Canal & River Trust)

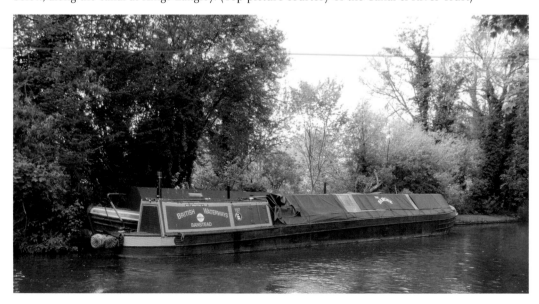

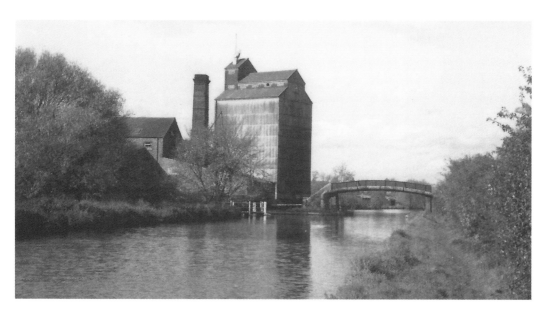

Toovey's Mill

Although there is evidence that a mill existed on the site at the time of the Domesday survey of 1086, Toovey's flour mill was started in 1778 following the marriage of Thomas Toovey to Esther Surrey, whose late father John had been the existing miller in Kings Langley. In 1846, the mill was sold to the Grand Junction Canal Company for £15,000 with a twenty-one-year lease, which was granted back to Thomas's son, also a Thomas, for £300 per annum.

By 1898, the mill had passed to Thomas William Toovey. With the business now thriving, especially with their top-grade 'Golden Spray' flour, production had increased by 1914 to eight sacks an hour, each sack weighing 2½ hundredweight. In 1978 the company went into voluntary liquidation with the mill and the giant grain silo, pictured above in 1958, being demolished. The whole site was then redeveloped for residential housing, although the old mill house still survives. (Top picture courtesy of David Spain)

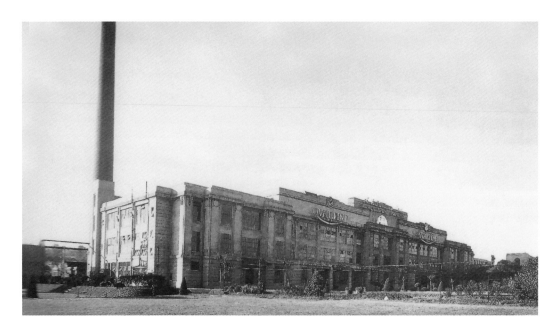

The Ovaltine Factory (1)

In 1865 Dr George Wander, a young chemist, founded a firm in Switzerland to market a malt extract drink that was beneficial in reducing the high infant mortality rate that was prevalent at the time. This amazing health drink was to be called Ovaltine. It wasn't until 1909 that his son Albert set up A. Wander Limited in Britain, later moving to Kings Langley in close proximity to the Grand Junction Canal – a ready-made means of transporting coal from the Warwickshire collieries. The factory, with its magnificent art deco-style façade was completed in 1913 when the first tin of British Ovaltine was produced. In order to maintain a constant supply of coal, it was decided that A. Wander Limited would purchase its own fleet of narrowboats, with the boat builders W. H. Walker & Brothers Ltd being commissioned to provide the boats from their Rickmansworth yard. (Top picture courtesy of David Spain)

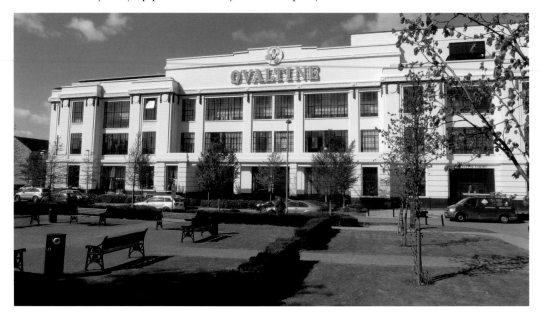

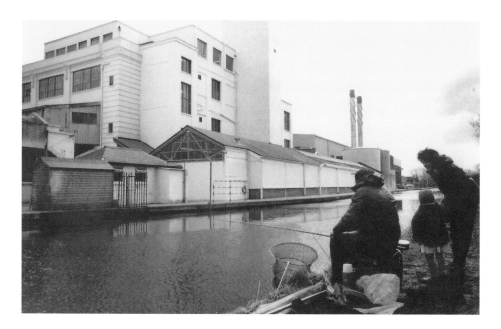

The Ovaltine Factory (2)

An angler is seen above enjoying a day's fishing in the canal at the rear of the factory. Between 1926 and 1929, W. H. Walker & Brothers Ltd were able to supply a total of eight pairs of narrowboats. This enabled the fleet to supply virtually all of the factory's coal requirements. By tradition, the motorboat at the front was always given a boy's name while the unpowered butty towed behind was given a girl's name. Although the business thrived, a decision was made to close the factory, which had produced Ovaltine since 1913, in May 2002 with the loss of 245 jobs. A sad day indeed for the local community. The production line was transferred to the company's Swiss outlet at Neuenegg, which had been taken over from Nestle in 1927. This factory would remain open. The 15-acre Ovaltine site was eventually purchased by Fairview New Homes with plans for industrial and housing development.

The distinctive façade of the original building was retained as a frontage to a superior block of apartments, with the rear now completely transformed. (Top picture courtesy of David Spain)

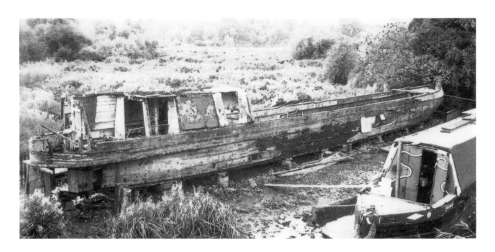

Albert

The first pair of narrowboats supplied to A. Wander Limited from the W. H. Walker boatyard in 1926 was *Albert* and its butty *Georgette*. Although *Georgette* was broken up in 1945, *Albert* survives to this day – though the outcome could well have been very different. In 1958 *Albert* was sold and renamed *Pearl Hyde* after the Lady Mayoress of Coventry and was used for canal cruises in the Coventry area. Sadly, age was starting to take its toll on the old narrowboat and, with so much decay, it was decided to scrap her. Fortunately, two canal boat enthusiasts came to the rescue just in time after discovering the rotting derelict hull (above) on the Trent and Mersey section of the Grand Union Canal. Using traditional tools and materials, the restoration process commenced with the relaunch taking place in September 1990.

Now completely transformed, it was a proud moment indeed for the owner when *Albert* headed the parade of boats for HM Queen Elizabeth II at her Diamond Jubilee celebrations at Henley in 2012, as seen below. (Top picture courtesy of Tim Woodbridge and David Spain, bottom picture courtesy of Tim Woodbridge)

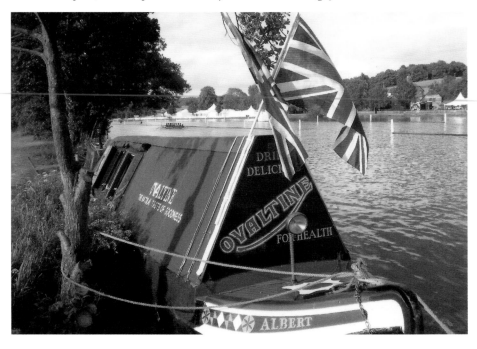

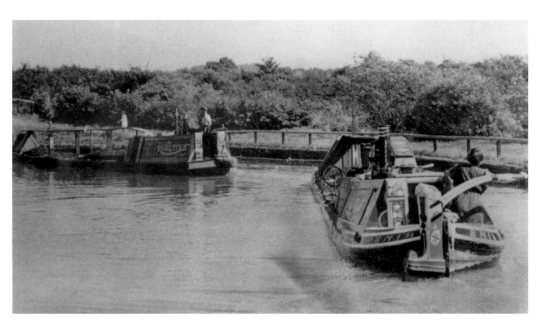

William and *Enid*

Two of the Ovaltine fleet of narrowboats, *William* and *Enid*, seen above with a cargo of coal for delivery to the Wander factory. The 1932 picture below shows both boats being unloaded at the factory wharf by a grab crane, before making the return journey to the coalfields for another shipment. (Pictures courtesy of David Spain)

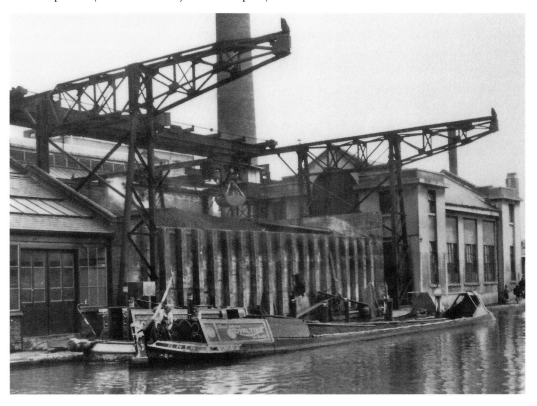

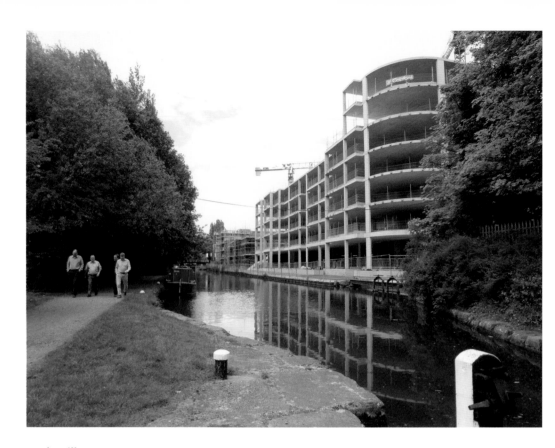

Nash Mill

Shortly after his marriage to Ann Grover in 1810, the twenty-eight-year-old John Dickinson purchased Nash Mill, about ½ mile downstream from Apsley, an existing paper mill that had the added advantage of a good millhouse and a pleasant garden. The mill had been converted to paper towards the end of the eighteenth century by the owner A. Blackwell and his partner G. Jones, having originally been a corn mill. Like Apsley Mill, it had been mentioned in Domesday and in the Middle Ages had belonged to the abbey of St Alban. A major fire that broke out on 26 October 1813 was a setback, but although the damage was £7–8,000 the insurance soon enabled redevelopment towards full-scale production again. Today, the mill wharves are no more as a comprehensive construction programme develops the area into luxury waterside apartments.

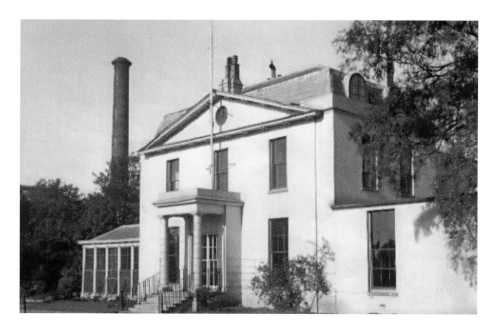

Nash Mill House

Nash Mill House, where John Dickinson and his wife first lived after their marriage, was a lovely stuccoed building with a southerly aspect that presented a pedimented façade, with long windows to the drawing and dining rooms, a pillared porch up a flight of steps and a long orangery that leads out to well-manicured lawns kept short and smooth by the mill boatmen using scythes.

The photograph above was taken around 1930, while the post-1937 aerial view shows Nash House as the white building in the centre of the picture. With the current redevelopment of the Nash Mill site, the old house is to be retained for residential purposes. (Pictures courtesy of the Apsley Paper Trail)

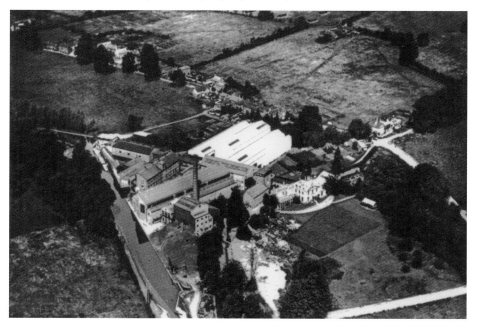

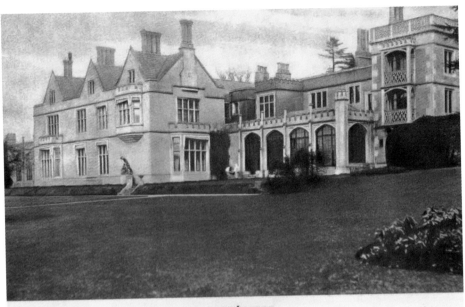

9. ABBOT'S HILL
built by John Dickinson in 1836

Abbot's Hill

In 1836, John Dickinson began to build for himself and his family a fine new house, which he called Abbot's Hill – believed to have been the inspiration for Charles Dickens' novel *Bleak House*. Set in 125 acres on a hill overlooking Nash Mill, the lavish dwelling lent itself to entertaining as Dickinson believed in hospitality, especially where business was concerned. John Dickinson had a theory that no house should have more than one door to the outside world and remained faithful to it for the rest of his life, only ever having one impressive oak external door. Abbot's Hill, now an independent girls' school, celebrated its centenary anniversary in 2012 having been founded on the present site by Alice, Katrine and Mary Baird, to whom it had been sold by John Dickinson's great-grandson. (Top picture courtesy of the Apsley Paper Trail)

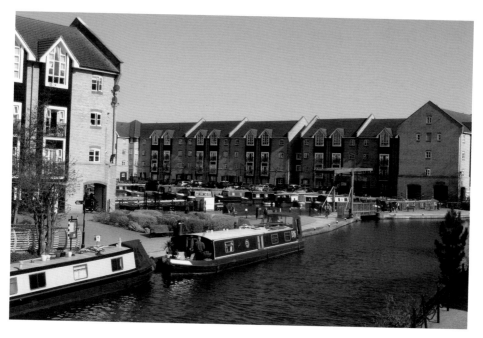

Apsley Marina

These two lovely views show Apsley Marina in the top photograph, a superior mooring where a range of facilities are on offer to the boater including a chandlery, laundry, pump-outs, showers, a water point and a pub/cafe. Access to the marina is via a lift bridge at the entrance from the canal. Built in 2003 from redeveloped land following the closure of John Dickinson's Apsley paper mill, the marina basin is now surrounded by fashionable apartments, restaurants and shops. The image below depicts the aptly named Paper Mill public house, a popular canalside venue, with one of the old Apsley Mill buildings that survived the demolition of the site that started in 1992 now used as office accommodation.

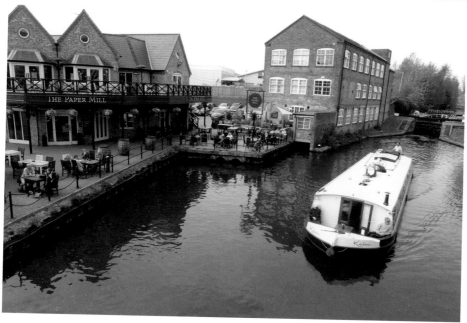

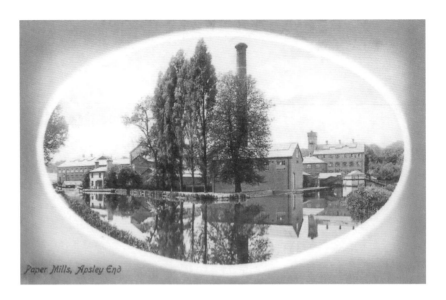

Paper Mills, Apsley End

Apsley Mill (1)

In 1798 a Frenchman, Nicholas Louis Robert, invented a process whereby paper could be made in continuous lengths, a process that was developed in England by two London stationers – Henry and Sealy Fourdrinier. The first paper to be made in this format by machine was produced at Frogmore Mill, Apsley in 1803. By 1810, the enormous cost of this venture had bankrupted the Fourdriniers and the mill was eventually procured by the British Paper Company. It was in 1809 that John Dickinson acquired Apsley Mill, an old flour mill that had almost certainly been one of the two mills mentioned in Domesday. Having little capital of his own, Dickinson took on a partner, George Longman, a man of substantial means.

With this financial backing, it meant that instead of small quantities of handmade material, it was now possible to mass produce paper on huge reels. The images show Apsley Mill, above, in its heyday, with the bottom picture showing part of the only remaining factory building as it appears today. (Above picture courtesy of the Apsley Paper Trail)

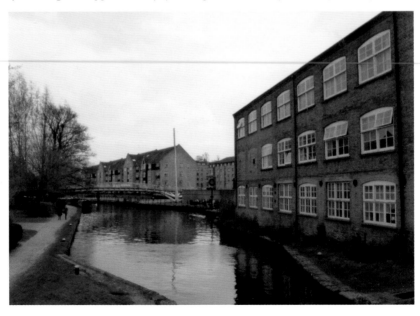

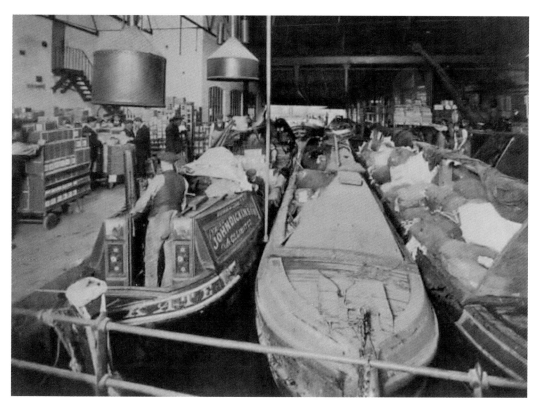

Apsley Mill (2)

The two images illustrated show the loading bay at Apsley Mill in 1916, above, and the overnight narrowboat departing with paper being transported to Paddington in London. (Pictures courtesy of the Apsley Paper Trail)

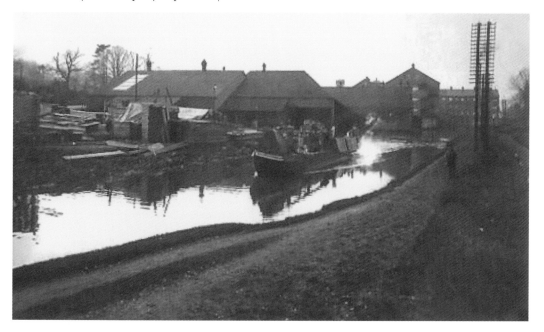

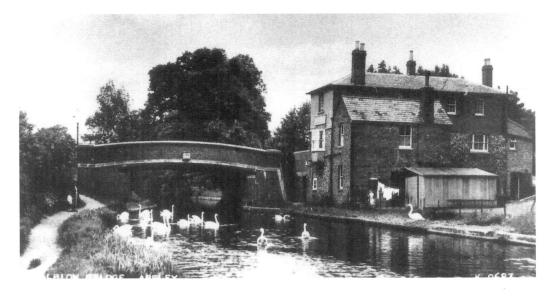

The Albion Inn, Apsley

Situated adjacent to Bridge No. 152, The Albion inn was built about 1836 by Thomas Ebbern, a prosperous coal merchant from Watford, together with wharves, cottages and other outbuildings – including stabling for three canal horses – on land previously part of Corner Hall Farm. Following Thomas Ebbern's bankruptcy in 1852, the property was sold by his creditors to help clear his outstanding debts. Beer sellers during the latter part of the nineteenth century included James Turnham, Henry May and A. Simpson. The public house was demolished in the late 1990s, with residential housing now occupying this attractive setting. (Top picture courtesy of HHLH&MS)

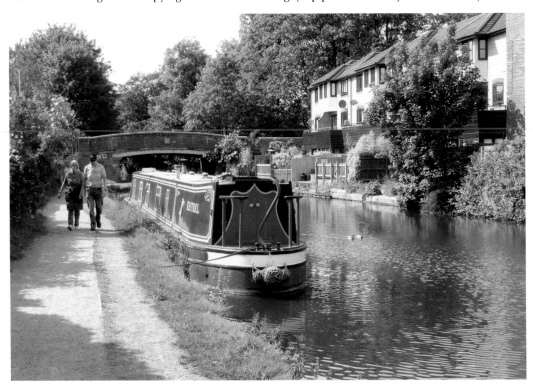

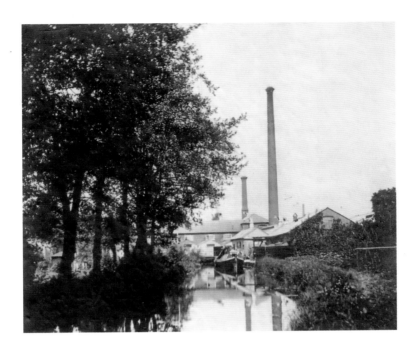

Frogmore Mill (1)

Frogmore Mill, like so many other mills, was once a corn mill grinding grain to make flour. Records indicate that a fulling mill, where woollen cloth was prepared, occupied the site in 1289, with the 'fulling' process used to remove oil and other impurities. In 1803, Henry and Sealy Fourdrinier installed the world's first commercial, mechanised papermaking machine that could produce continuous paper in rolls, though with the high costs involved (£60,000) the two brothers went bankrupt. Frogmore Mill is on an island in the River Gade with the water just below the mill joining the Grand Union Canal. For many years, the Grand Junction Canal, as it was then known, owned the mill until the British Paper Company was established in 1890 and fully purchased the mill in 1929. Today, still making paper after over 200 years, Frogmore Paper Mill, seen below, is now operated by the Apsley Paper Trail, a charitable trust. (Top picture courtesy of the Apsley Paper Trail)

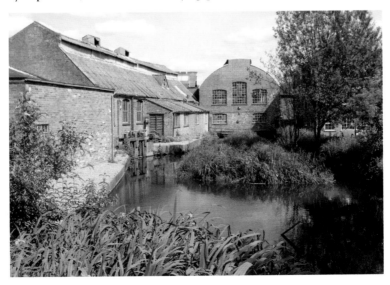

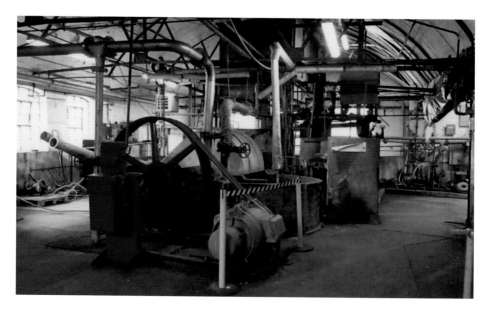

Frogmore Mill (2)

The Hollander Beater above dates back to the 1930s and consists of a roll fitted with bars, turning in an oval tub, and a pocket below the roll fitted with fixed bars. The roll pushes water round the tub and about 6 per cent of fibre is added. The movement of the two sets of bars teases out individual fibres, increasing their surface area and flexibility. The result is a bond that produces stronger paper. The No. 2 Fourdrinier machine below was installed second-hand in 1907 by the British Paper Company.

Although having had several major refits, the machine remains much as it was when built in 1896. It has a Fourdrinier-type wet-end, with deckle straps and a jacketed top couch, a single plain press, eighteen drying cylinders and two callender stacks. At maximum speed, the machine can produce an impressive 200 feet of paper per minute and 2.2 miles per hour, which equates to 18 miles in a shift. (Pictures courtesy of the Apsley Paper Trail)

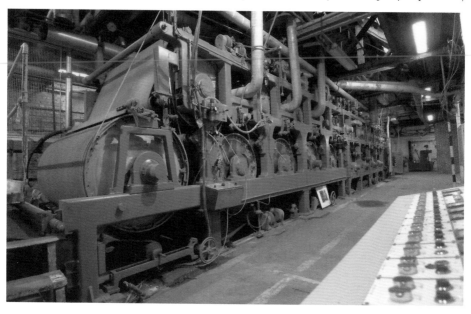

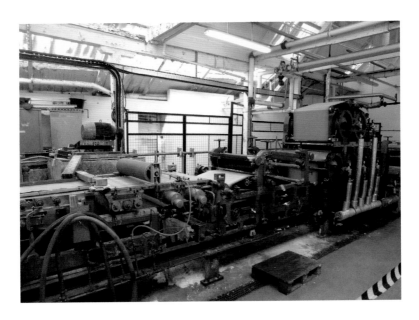

Frogmore Mill (3)

Built in Germany in 1902 for what was then The Manchester Institute, the Pilot Fourdrinier was donated to the Paper Trail charity in 2004. Despite being relatively small in size, the machine is complex and requires considerable skill and knowledge to operate. It has 200 points of adjustment, with the four main variables to control being pulp flow, dilution water flow, machine speed and steam flow to the 'dry end'. Although only able to produce relatively short runs, these are of exceptionally high-value special content board with the price being five times that of ordinary paper. In the picture of the mill race, the water can be seen flowing through the mill with the holes in the side walls housing the axles on which the water wheels were mounted. The two wheels ran independently, with one wheel used to pulp rags and the other to drive the paper machine. Stonework to the base of the wheel pit has been dated to 1700.

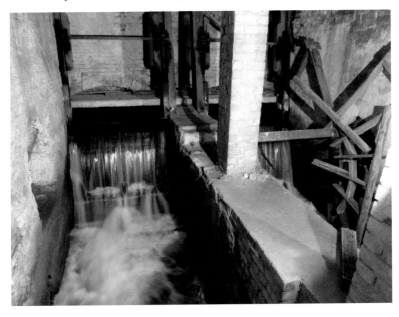

Kents Brush Works, Apsley End - 10.6.1.91

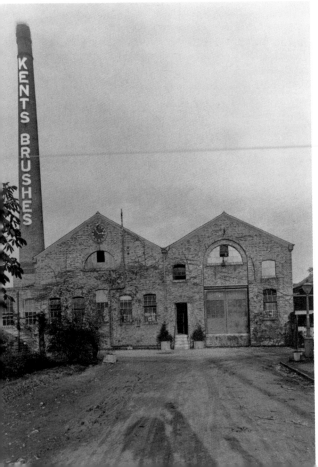

Kent Brushes (1)

G. B. Kent & Sons Ltd, or Kent Brushes as it is more commonly known, was founded in 1777 by William Kent, producing high-quality brushes from their London premises in Great Marlborough Street. Their reputation grew, so much so that they were honoured with a Royal Appointment to Queen Victoria, with Medals of Excellence being presented to the company at the Great Exhibition of 1851.

In 1901, Kent & Sons moved to Apsley where factories were built alongside the River Gade, which links with what was then the Grand Junction Canal. This prestigious firm continues to prosper today producing first-class quality products. The old buildings, as seen in these two images, were demolished in the 1980s, including the iconic chimney – a local landmark for so many years. (Pictures courtesy of HHLH&MS)

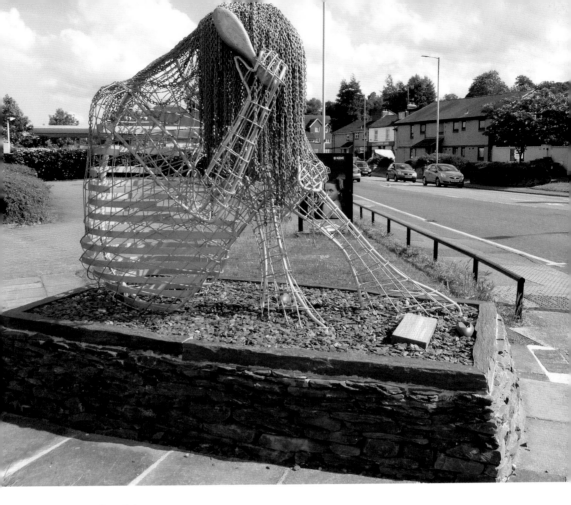

Kent Brushes (2)

A new landmark has now appeared in front of the modern Kent Brushes factory in Apsley, a giant metal structure showing a lady brushing her hair with a large brush. This eye-catching and impressive edifice is a welcome addition to the local company since the 200-foot factory chimney with 'Kents Brushes' picked out in white lettering down the side was demolished, together with other old buildings, over thirty years ago.

Boxmoor Wharf

Built by the Boxmoor Trust, the wharf at Two Waters Bridge No. 151 was originally the main coal wharf for Hemel Hempstead. In 1864 Henry Balderson imported wine and spirits there, as well as dealing in other commodities such as coal and coke. Following the Second World War, in 1947 L. Rose & Company, the producers of Rose's Lime Juice, took out a lease on the wharf where lime juice destined for the company's manufacturing plant in St Albans arrived by narrowboat in large oak casks from the London Docks, following shipment from Dominica. A B&Q retail outlet now occupies the site.

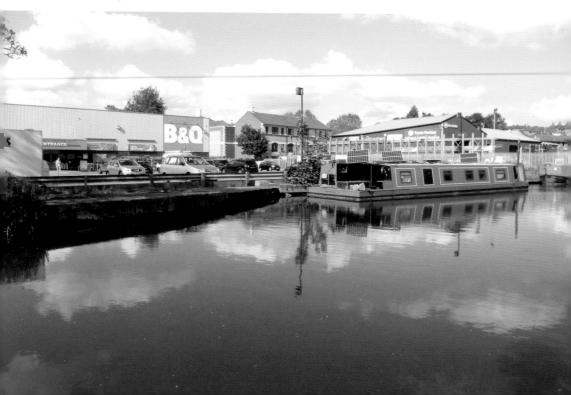

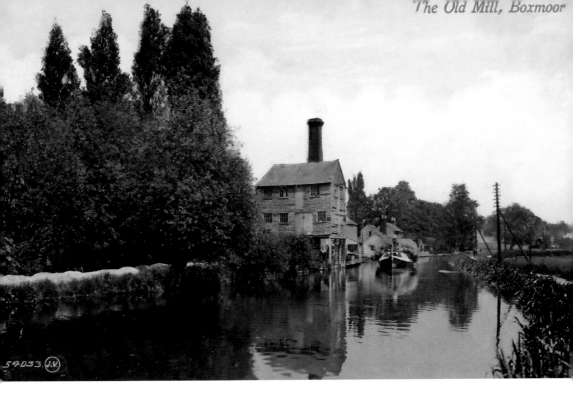

Foster's Saw Mill

This old saw mill depicted above in a postcard dated 5 September 1911 was a familiar sight on the banks of the canal at Boxmoor until it was destroyed by fire in 1967, with its subsequent demolition occurring two years later. The mill had changed hands several times over the years, with Henry Foster recorded as the proprietor in 1850. During the First World War, Foster's contributed greatly to the war effort by producing, among other woodwork items, ammunition boxes for the Navy called 'Ditty Boxes'.

Several blocks of attractive flats known as River Park have now been built on the site, partly obscured behind the trees below.

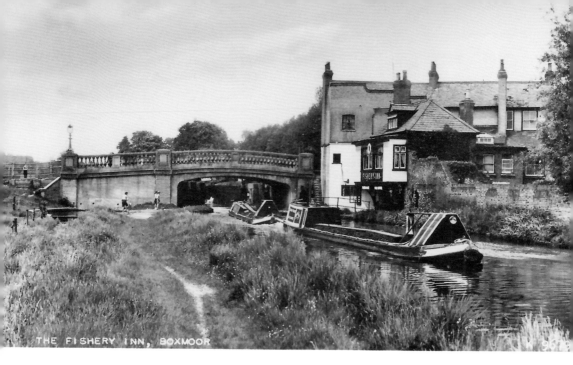

THE FISHERY INN, BOXMOOR

The Fishery Inn

This popular canalside tavern, established in the early 1800s, once offered stabling for the passing narrowboat tow horses, with a local blacksmith on hand at the nearby Fishery Forge. Despite the attractive stone balustrade bridge featured in the top image now having been replaced by a modern reinforced concrete structure, this charming old pub and restaurant, with its superb menu, nevertheless provides a pleasant venue to both boaters and visitors alike.

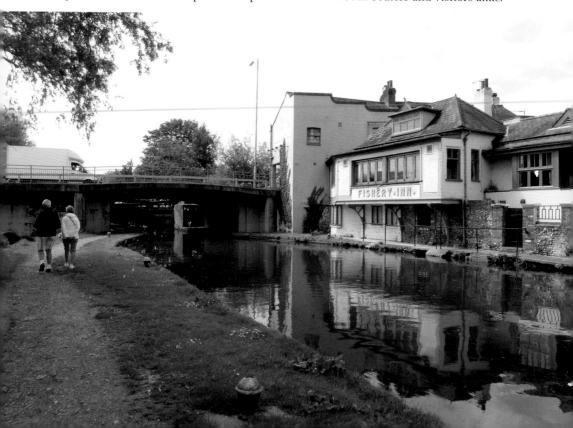

FISHERY INN

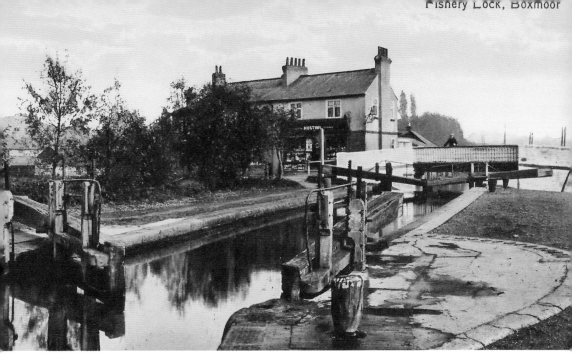

Learning the Ropes

This young lad, nine-year-old Liam Tonner, is seen below helping a weekend boater push open the balance beam at Lock No. 63, Bridge No. 149. Who knows, perhaps this small act may well generate a lifetime interest in the waterway? The early picture of The Fishery Inn above, shown from the other side of the bridge, indicates a small shop, now long gone, where boat people could obtain their provisions.

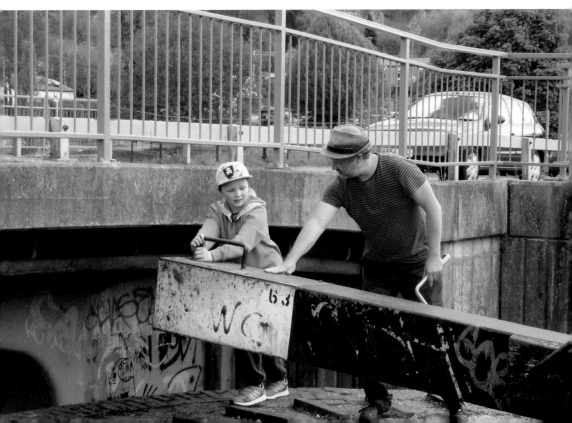

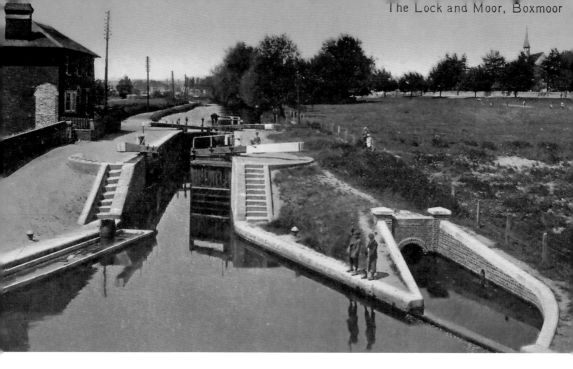

Lock No. 64 (1)

When comparing these two images, captured around a hundred years apart, the change to this delightful panorama is quite dramatic. The extensive growth of mature trees and vegetation has now replaced the previous uninterrupted view across the moor to St John The Evangelist church, Boxmoor, in the distance.

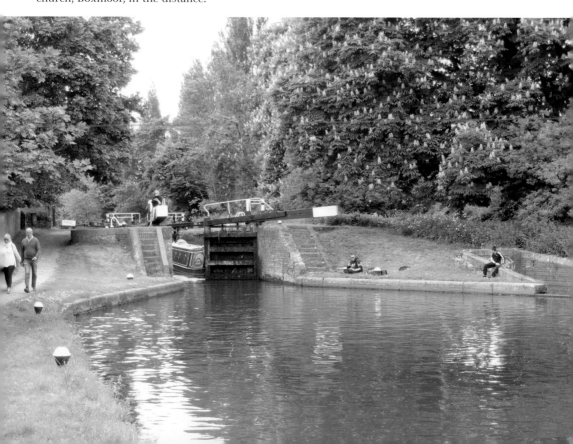

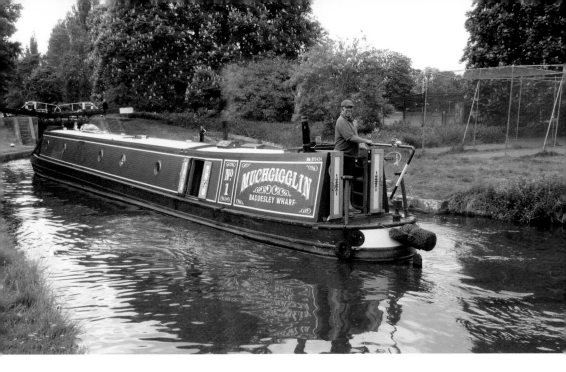

Lock No. 64 (2)

One of the well-known boaters on the waterway system is Tone Ferne, seen above on his 70-foot narrowboat *Muchgigglin* about to enter Lock No. 64, accompanied by his wife Julie, en route to Braunston. This sleek craft built by the Barry Hawkins boatyard in 2005 has a Russell Newbery DM2 2-cylinder diesel engine generating 19 hp with a top speed of 850/900 revolutions per minute. Not only is Tone a keen boater, he is also an experienced and fully qualified sound engineer, having participated in many recording sessions with some of the top bands in the world. With the lock keeper's cottage now demolished, all that remains is the wrought-iron railings (below) that surrounded the property.

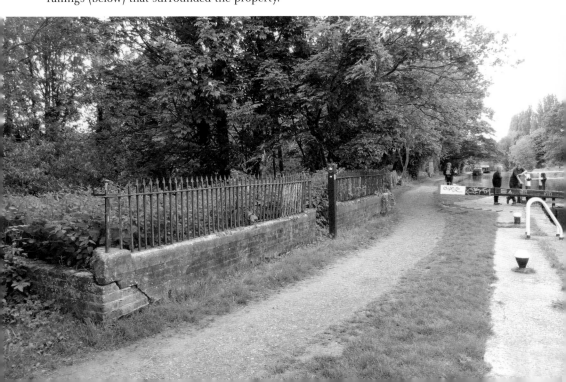

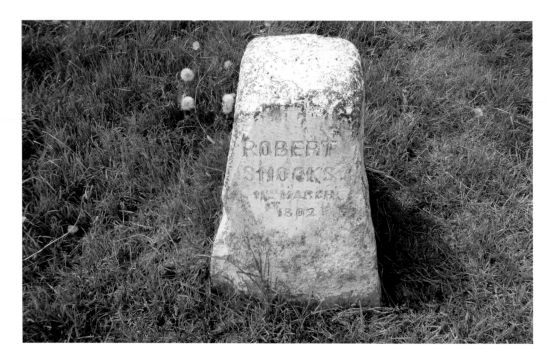

James Snook – Highwayman

In a buttercup-strewn grassy meadow near to the canal towpath in Boxmoor, the mortal remains of James Snook, the last man to be executed at the scene of his crime in England for highway robbery, lies buried. Born in Hungerford around 1761, Snook robbed a mounted post boy, John Stevens, who was carrying the mail from Tring to Hemel Hempstead on 17 May 1801. Following his capture in Marlborough Forest on 5 December 1801, Snook was tried at Hertford assizes, found guilty and sentenced to death. It was stipulated that the highwayman should be executed close to where the crime occurred at Boxmoor. On 11 March 1802, thousands of people turned out to witness the hanging.

In 1904, the Boxmoor trustees placed some stones on the spot to commemorate the grisly event. One of the stones has the legend 'Robert Snooks 11 March 1802' inscribed on it, with the 'Robert' perhaps corrupted from his identity as 'Robber Snooks'.

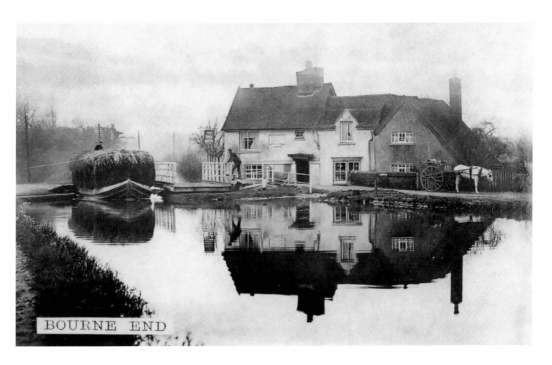

BOURNE END

The Three Horseshoes, Winkwell (1)

Leaving Lock No. 61 we approach Bridge No. 147, a key-operated, electrically controlled swing bridge that moves to one side, thus allowing canal boats to pass through, although vehicular traffic on the road is temporarily held up until the bridge returns to its normal position. The delightful waterside pub, a popular venue for boaters and visitors alike, is the Three Horseshoes at Winkwell, a name that originates from an old English word meaning a 'corner' and a 'well' or 'spring'. Parts of this old inn date back to 1535. (Top picture courtesy of HHLH&MS)

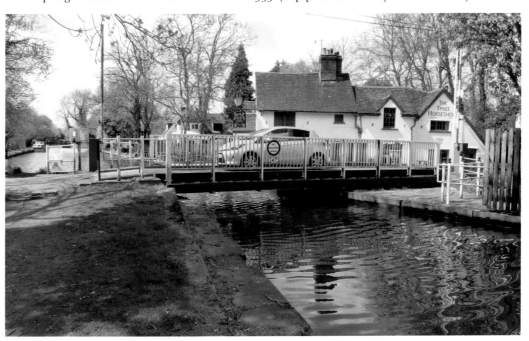

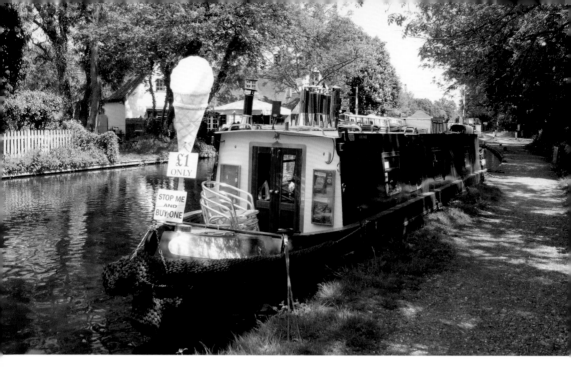

The Three Horseshoes, Winkwell (2)

The entrepreneurial owner of this narrowboat not only sells ice cream to passing boaters, as denoted by the large cone and the legend 'Stop Me and Buy One', but also teas and cakes as well. A further indication of the boater's skills are the numerous stainless-steel artefacts on display, all available to purchase by canal folk and the many walkers who stroll along the towpath. Below, a further glimpse of this charming pub shows a group of people enjoying a relaxing lunchtime in the spring sunshine.

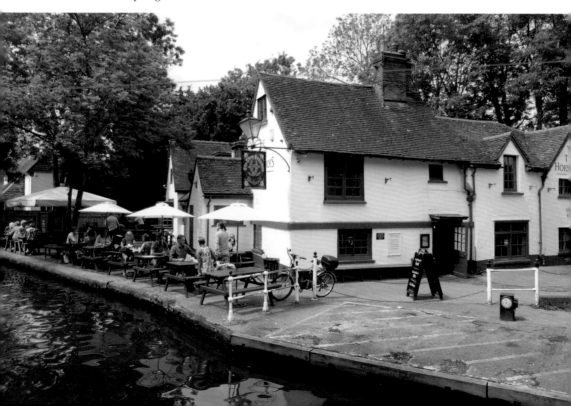

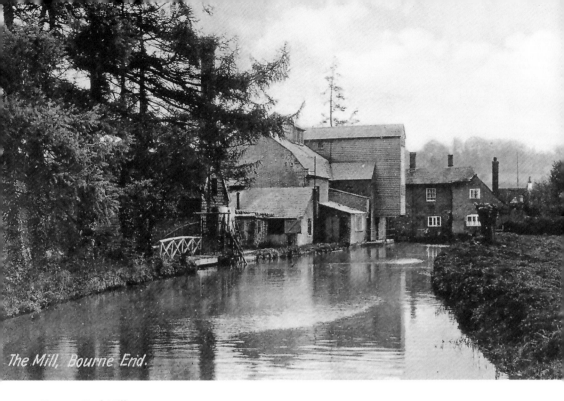

The Mill, Bourne End.

Bourne End Mill

In 1893, James Goodall Knowles, a local farmer and corn merchant of Broadway Farm, took out a long lease on Bourne End Mill between Berkhamsted and Boxmoor. At the time, the mill contained three pairs of mill stones, which he replaced with a new roller mill in 1900, as well as adding an oil engine to the power already provided by the waterwheel. The mill ceased functioning in 1945, with part of the building being subsequently destroyed by fire in 1970. The site was developed into a hotel two years later. (Top picture courtesy of HHLH&MS)

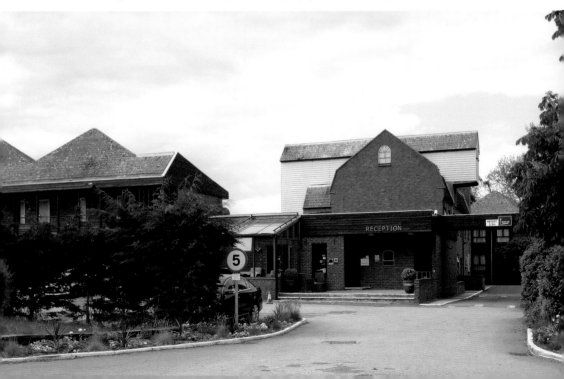

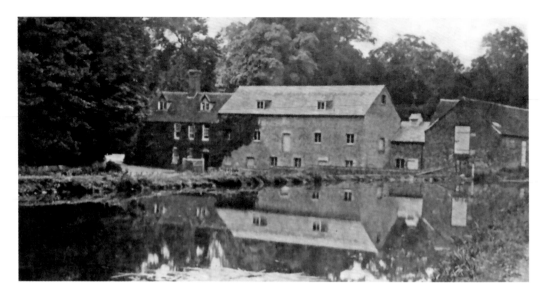

Lower Mill, Berkhamsted

Lower Mill, or Bank Mill, believed to have been mentioned in the Domesday survey of 1086, was situated at what is now the junction of the high street and Bank Mill Lane on the site now occupied by the Old Mill restaurant. Sometime during the 1890s a serious fire badly damaged the waterwheel and machinery, bringing milling to a halt, and it is doubtful whether the mill became operative again. By the early 1900s, the River Bulbourne had started to dry up, which would have meant that there was insufficient water to drive the wheel had milling recommenced, making closure a certainty. Considerable traces of the mill race and wheel pit still survive to this day. The modern-day images of the mill shows the rear elevation (below) and the frontage (inset). (Top picture from the collection of BLHMS)

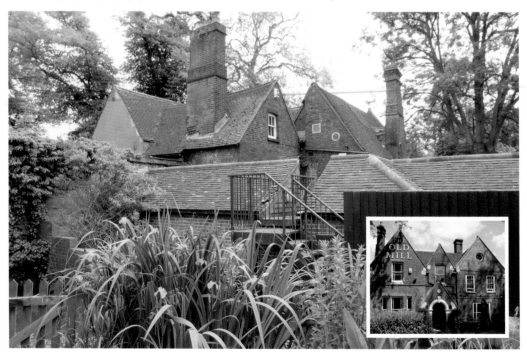

Cooper's Wharf, Berkhamsted

In 1852, a small factory was set up in Ravens Lane by William Cooper, a veterinary surgeon, to experiment and produce the world's best-known and most-effective sheep dip, a powder containing the key ingredients of arsenic and sulphur. By 1864, the factory was steam-powered using coal delivered by narrowboat along the canal, with the finished products leaving the same way. In 1925, the company amalgamated with McDougall and Robertson to become Cooper, McDougall & Robertson Ltd. Like so many other of the old buildings, mills and wharves along the canal, the site has now been redeveloped into housing.

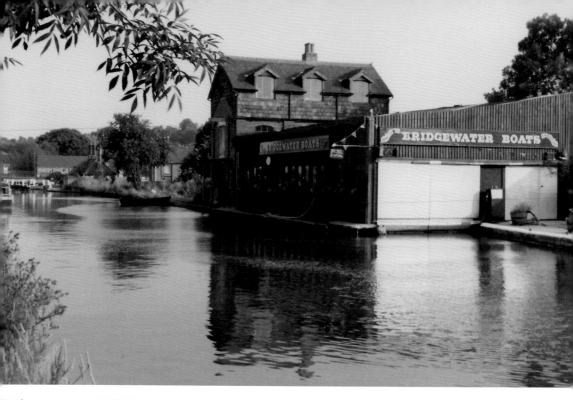

Bridgewater Boats

With the demise of traditional working craft on the inland waterways network, and the emerging pleasure boat business that was starting to gain in popularity during the 1960s, Castle Wharf in the once thriving Port of Berkhamsted was purchased by the current owners in 1976 in order to run their boat company – Bridgewater Boats. In the same year, the original slipway was renovated and was in constant use for the holiday hire fleet, and for the servicing of third-party craft. In addition to being one of the foremost canal holiday operators on the waterway, Bridgewater Boats also undertook engine maintenance, engineering and welding, superstructure paintwork and traditional boat decoration.

Now that the port has lost its many working wharves, Castle Wharf is the last one remaining in Berkhamsted. The Bridgewater Boats workshop and slipway is now protected by planning law and can only be used for commercial boating purposes. (Pictures courtesy of Lindy Foster Weinreb)

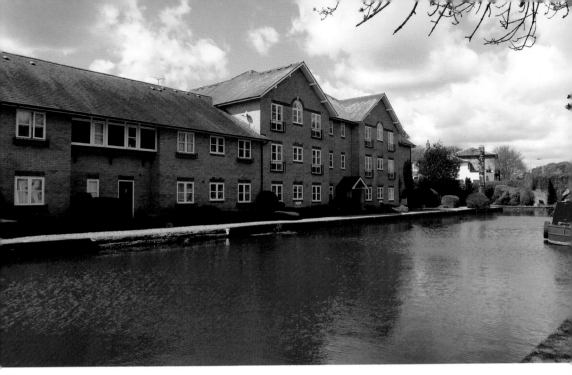

Costin's Boatyard

One of several boat-building firms along this stretch of the canal, Costin's had a fine reputation for high-quality workmanship, building boats for some of the well-known carrier companies of the time, including Fellows, Morton & Clayton. Delightful waterside properties have now replaced the old boatyard, along with an impressive-looking 27-foot tall totem pole (below) made from Canadian red cedar and carved by Henry Hunt, a Kwakiutl Native American from Vancouver Island, Canada. The totem pole was erected on the site in 1970 as a memento from the family of the J. Alsford timber company.

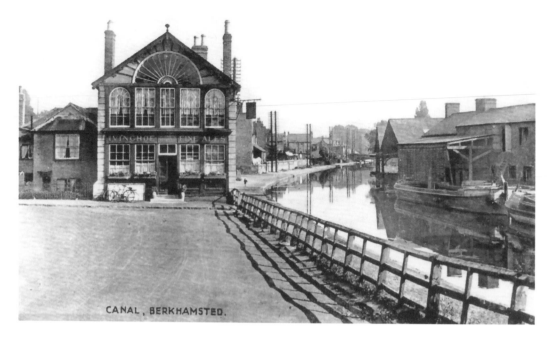

CANAL, BERKHAMSTED.

The Crystal Palace

The Crystal Palace public house, built in 1854, originally had a glazed frontage that was inspired by the Great Exhibition building of 1851, designed by Sir Joseph Paxton. Paxton's nephew, William, was land agent to Lord Brownlow, who lived at nearby Ashridge House. One of three pubs located alongside the waterway in Berkhamsted, the Crystal Palace is seen above facing Costin's Boatyard on the other side of the canal, probably in the late nineteenth or early twentieth century. All three hostelries, including the Rising Sun and the Boat, provide a delightful venue to sit and while away an hour or so watching the many narrowboats passing, especially at weekends when the water traffic is at its busiest. (Top picture from the collection of BLHMS)

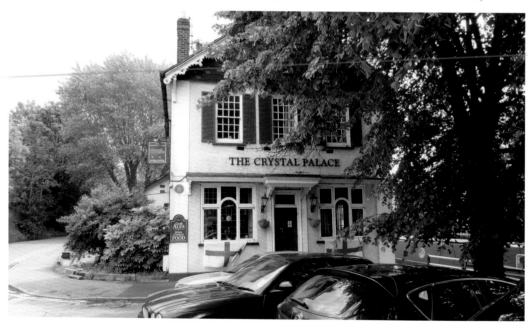

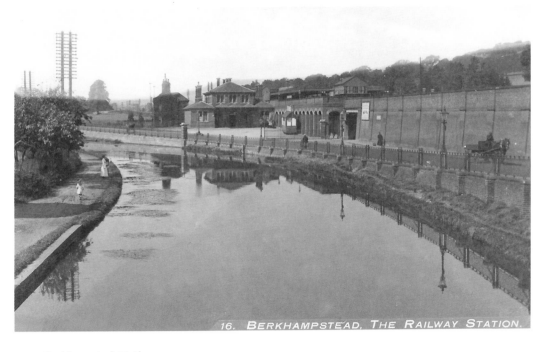

16. BERKHAMPSTEAD, THE RAILWAY STATION.

Berkhamsted Station

The present-day Berkhamsted railway station dates from 1875 and is located on Lower Kings Road at the junction with Brownlow Road, a short distance from the town's castle remains. Despite much opposition from local landowners and turnpike trustees, the project received royal assent in 1833, with the first train passing through Berkhamsted on 16 October 1837 59 minutes after leaving London. The coming of the railway was, of course, a very real threat to the existence of the Grand Junction Canal, and its main response to the railways was to reduce the tolls charged to its traders from 84½ pence to 67½ pence per ton. Several restrictions on the use of the canal were lifted – it was now open to traffic 24 hours a day.

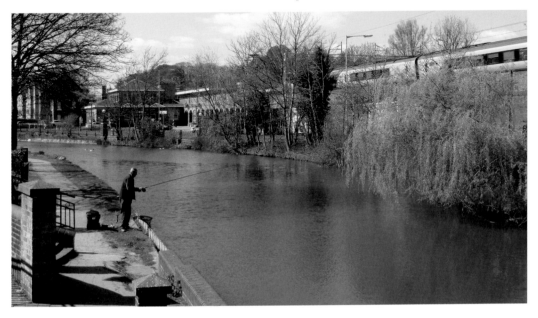

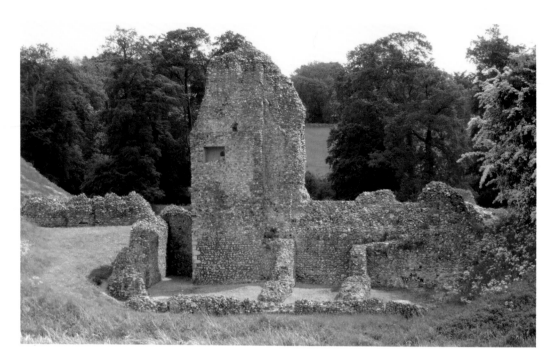

Berkhamsted Castle

This historic ruin at Berkhamsted is a unique example of a Norman motte-and-bailey castle where the motte, or mound, is a fortification with a keep of wood or stone located on a raised earthwork, accompanied by an enclosed courtyard or bailey. Following the defeat of King Harold at the Battle of Hastings on 14 October 1066, William, Duke of Normandy, marched with his army through southern England eventually arriving in Berkhamsted where, because of its strategic importance, a Saxon fort already existed guarding the main route north through the valley. The above image indicates a tall piece of flint wall, part of the palace tower, together with the rectangular remains of a small chamber, with the picture below portraying the mound.

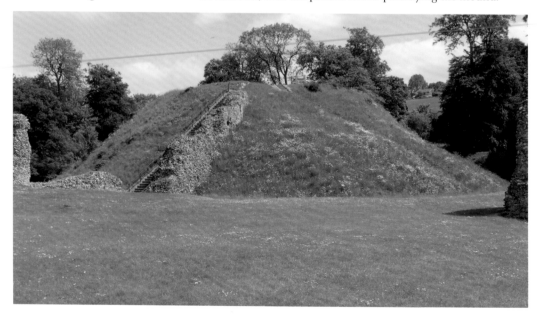

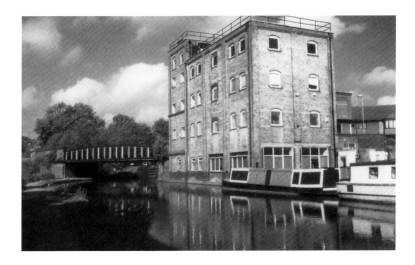

Castle Mill

In 1910, Berkhamsted's third mill was constructed by E. R. & F. Turner adjacent to the canal in Lower Kings Road for Alfred Knowles, the son of the late miller James Goodall Knowles of Broadway Farm. The siting of the new mill, known as Castle Mill, was such as to take full advantage of the transport facilities offered by both the canal and the nearby railway. The business was started by James Goodall Knowles, who had successfully run the mill at Bourne End, although his son Alfred eventually took over the practical management of both mills as a single enterprise. The basement of Castle Mill contained a National Gas engine and suction gas plant and, having a concrete ceiling, this prevented a fire in the basement from spreading to the rooms above. The business was engaged in the grinding of a variety of grains and the manufacture of animal feed. This impressive-looking building is now occupied by office accommodation. (Top picture from the collection of BLHMS)

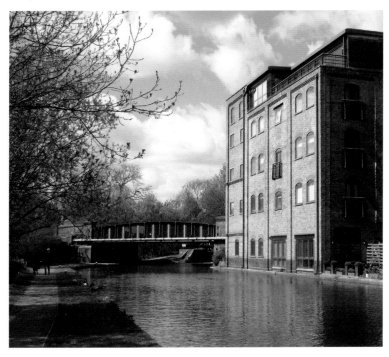

Lock No. 53
Taken on a bright spring day from the direction of Canal Fields, these two lovely images of the waterway in Berkhamsted show Lock No. 53, with the distinctive Bridge No. 140C in the background. The prominent building to the left of the bridge is Castle Mill.